STAN HYWET HALL & GARDENS

OHIO HISTORY AND CULTURE

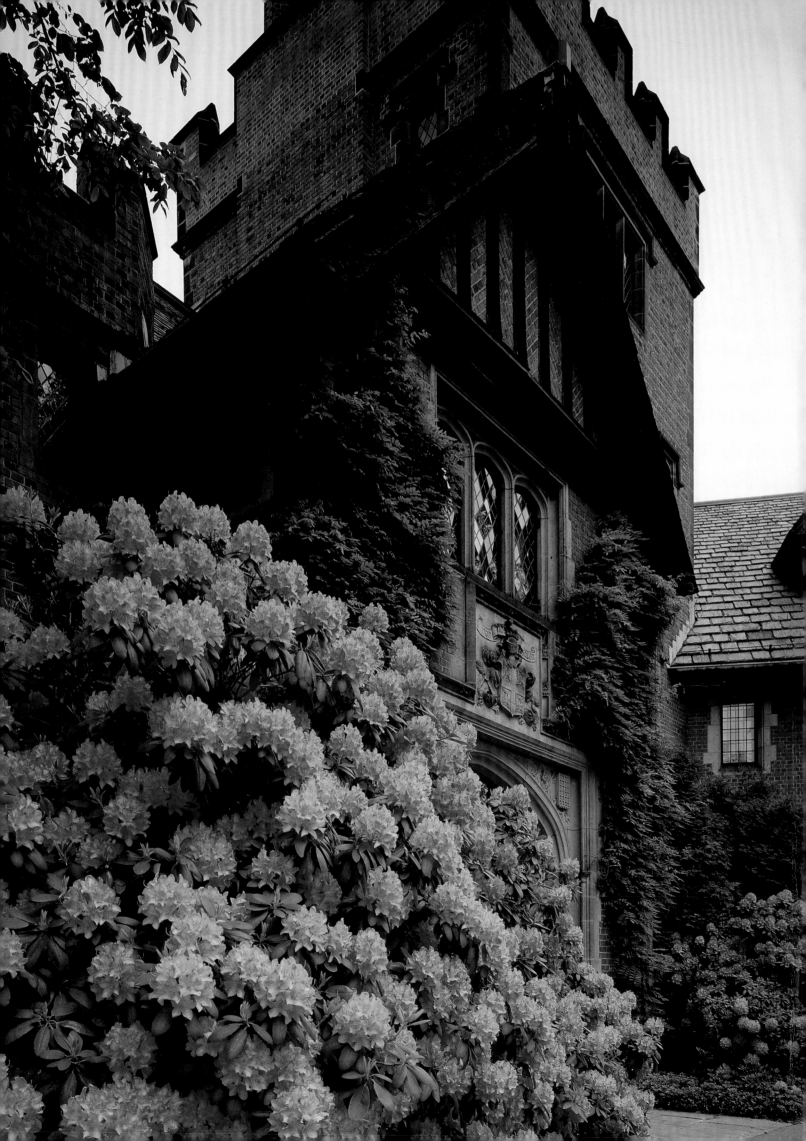

STAN HYWET HALL
& GARDENS

Photographs by Ian Adams and Barney Taxel

Text by Steve Love, with a Foreword by John Seiberling

The University of Akron Press
Akron, Ohio

All inquiries and permissions requests should be
addressed to the publisher, The University of Akron Press,
Akron, OH 44325-1703

Printed in China

First Edition 2000

14 13 12 11 10 6 5 4 3

Library of Congress Cataloging-in-Publication Data
Adams, Ian, 1946–
 Stan Hywet hall & gardens / photographs by Ian
Adams and Barney Taxel ; text by Steve Love, with a
foreword by John Seiberling.—1st ed.
 p. cm. — (Series on Ohio history and culture)
 Includes bibliographical references and index.
 ISBN 1-884836-59-3 (cloth : alk. paper)
 ISBN 1-884836-60-7 (pbk. : alk. paper)
 1. Stan Hywet Hall (Akron, Ohio) 2. Stan Hywet Hall
(Akron, Ohio)—Pictorial works. 3. Gardens—Ohio—
Akron. 4. Gardens—Ohio—Akron—Pictorial works.
5. Architecture, Tudor—Ohio—Akron—Pictorial works.
6. Architecture, Domestic—Ohio—Akron—Pictorial
works. 7. Seiberling, Frank A. (Frank Augustus), 1859–
1955. 8. Akron (Ohio)—Buildings, structures, etc.—
Pictorial works. I. Title: Stan Hywet hall and gardens.
II. Taxel, Barney, 1949– III. Love, Steve, 1946– IV. Title.
V. Series
 F499.A3 A25 2000
 977.1'36—dc21 99-055416

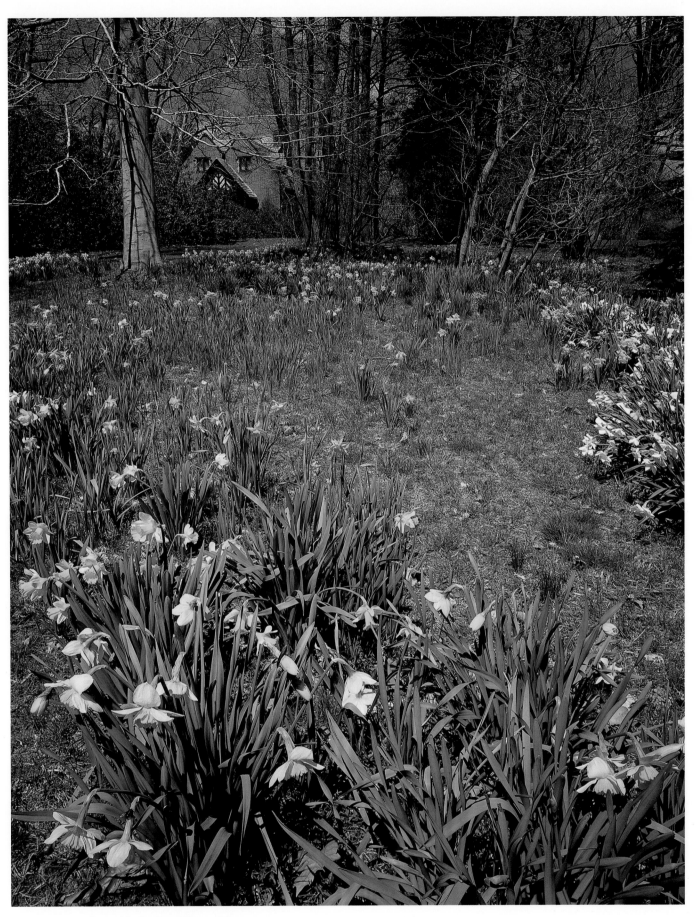

Daffodils South of Manor House

 Stan Hywet Hall and Gardens is a very special place. It is special because of its extraordinary architecture, spectacular gardens, fine collections, and, most important, the very special people who have made it part of their lives. Certainly high on the list of these special people are Joe and Joanne LaRose.

Joe can be found most weekends working in the Carriage House Café or helping Guests Services guide and direct our visitors. If Joanne is not walking the gardens and grounds, she is guiding tours in the Manor House. Over the years, when they have seen a need, Joe and Joanne have always found a way to support Stan Hywet.

The creation of this book is just one such need. Without the support of the LaRoses, this book would not have become a reality. We are extremely grateful to Joe and Joanne for all the support they provide Stan Hywet and particularly for their assistance with the creation of this book about Stan Hywet Hall and Gardens.

 Stan Hywet Hall and Gardens dedicates this book to the memory of Carl D. Ruprecht (1960– 1999). For over fifteen years, Carl's passion for the natural beauty that abounds at Stan Hywet made him a devoted steward to the legacy of landscape architect Warren Manning. The joy that Carl experienced in caring for the Seiberling family gardens was boundless. So it was with the compassion and humility that graced Carl's daily interactions with family, friends, volunteers, and staff. The estate and all who delight in its natural treasures will remain touched by Carl's contributions. It is our hope that his spirit will remain vibrant through this landscape forever.

Front Entrance Gates at Night

CONTENTS

FOREWORD

John F. Seiberling

Most writings about life at Stan Hywet Hall focus on the lifestyle of its creators, Frank A. ("F. A.") and Gertrude P. Seiberling, including the many family gatherings and social events that were held there when it was a private residence during the years 1915 to 1957. But what was it like to grow up at Stan Hywet in those years?

F. A. and Gertrude had twenty-one grandchildren, all born after Stan Hywet was built. I was the first grandchild, born September 8, 1918, in the "Hospital Room," which occupied the top floor of the Manor House tower. My two sisters, Mary and Dorothy, were also born there.

Our father, John Frederick (Fred) Seiberling, was the eldest of the six living children of F. A. and Gertrude. Our mother, Henrietta Buckler Seiberling, came from El Paso, Texas, where her father, J. A. Buckler, had been a distinguished lawyer and judge. Henrietta, whose full-length portrait is at the head of the main staircase in the Manor House, was a beautiful, spirited woman, a Vassar College graduate, and an accomplished pianist.

Fred and Henrietta first met when he was on military duty with the Ohio National Guard during the 1915–16 Mexican border crisis. They were married in October 1917. By then the United States had entered World War I, Fred was in the army, and wartime travel was difficult. So the wedding was held at Stan Hywet, in the Music Room. By the time I was born, my father was already overseas with the American Expeditionary Force in France.

In 1923, after my two sisters had been born, we and our par-

ents moved from the Manor House, which we children simply called the "big house," to the Gate Lodge ("little house") next to Stan Hywet's grand entrance gate. It was our home for the next twenty-eight years. The Gate Lodge was a charming, if somewhat small, house for a family of five, and it gave us a degree of privacy that would have been lacking if we had lived in the Manor House, with its many family and social activities. We children, with a free run of the entire estate, indoors and out, had the best of both worlds.

We looked on Stan Hywet as a wonderful playground, where we were often joined by other kids in the neighborhood. There were secret passages to explore, trees and cliffs to climb, haylofts to romp in. We played games and put on plays in the Dell and the Japanese Garden. We fished for bass and bluegill in the Lagoon, using as bait earthworms we dug from the manure pile in back of the stable. The Lagoon was also the place where some of us learned to swim. Our choice of sports included croquet, tennis, and golf, the latter played on a four-hole golf course on the spacious front lawn. In the winter we went sledding on the gentle slope of the great lawn. The more daring among us tried sledding on a steep slope north of the Lagoon that we called "skiddy hill." It was aptly named. My sister Dorothy broke her wrist there when her sled skidded into a tree, and I broke a finger when my sled hit a stone. We also skated on the Lagoon when it was frozen solid, and sometimes had a wild game of ice hockey. In the summer and fall, we could eat our fill of strawberries, cherries, apples, peaches, pears, grapes, and other fruits from the orchards and gardens. We brought home apples, crabapples, currants, and gooseberries, from which our mother made delicious jellies, enough to last us a whole year. My sisters also earned some spending money selling their freshly picked berries to the neighbors.

By the mid-1920s, the riding horses were gone, but two huge Belgian Percheron workhorses, Mattie and Tom, were still working. Many a summer morning we would wake to the clump-clump sound of a horse's feet and the whirring blades of a large horse-drawn lawn mower criss-crossing the great front lawn. We kids had a Shetland pony, Rags, which became the pet of half the neighborhood. Garman Road, on the south border of the estate,

was still a dirt country road. Just down the road, Tommy Hughes, formerly the groom at Stan Hywet, ran a riding stable. There we could rent horses and ride over miles of beautiful bridle paths winding through the fields and woods stretching almost to the horizon west and north of Stan Hywet.

Although our grandparents were amazingly tolerant of children and wanted us to enjoy Stan Hywet to the fullest, they were sometimes dismayed by our adventurousness. One peaceful afternoon, our grandfather and some of his friends were having a quiet game of croquet on the north lawn when they looked up and beheld a frightening sight: both of my sisters, Mary and Dorothy, and a couple of neighbor girls were perched, four stories up, astride the peak of the north wing of the Manor House. F. A. and his friends waved their mallets and shouted to the girls to go back, which they proceeded to do. Presumably, the croquet game resumed.

Of course, life at Stan Hywet was not all just fun and games. Like everyone else, we children went to school and had to do homework and pass our courses. Our parents impressed upon us the importance of self-discipline, self-reliance, hard work, and respect for others. Nevertheless, living at Stan Hywet added some unique dimensions to our education.

Long before we began to appreciate the remarkable artistic elements at Stan Hywet, including its landscape, we accepted their beauty as part of our daily lives. Similarly, we accepted our grandparents as the generous source of many of our blessings. When the Great Depression struck in the 1930s, the Flint Motor Company collapsed and with it our dad's car dealership business. He was unemployed for over a year. We lived rent-free at the Gate Lodge, and our grandparents helped with living expenses, even though their own financial situation was precarious.

The depression forced F. A. to make some substantial cuts in the already reduced staff at Stan Hywet, including the gardeners. To help out, and also to earn some personal spending money, I applied to Mr. Ford Bachtel, the grounds superintendent, for a summer job as a gardener. I was hired but, being a teenage novice, was paid about $8.00 a week. The following summer, I worked there again as a gardener and was given a raise to $12.00 a week.

Working on the land at Stan Hywet gave me a new perspective as well as a much more detailed knowledge about the gardens themselves. I also got to know the other gardeners much better and developed a real feeling of camaraderie with them.

Some members of the Stan Hywet staff of the 1930s had a strong attachment to the place and continued to work there for years. Among them were Bill Hardman, who became grounds superintendent after Mr. Bachtel retired; Wilbur Turbeville, who, with his family, lived in the gardener's cottage next to the greenhouse, and Alexander Aitken, chief caretaker of the Manor House, who, with his family, lived in an apartment on the third floor. All three remained on the staff into the late 1950s or early 1960s.

Stan Hywet was not only a home and an artistic masterpiece, it was also a working farm. F. A. was born on a farm that his pioneer grandfather, Nathan Seiberling, had cleared of its forest cover in the early part of the nineteenth century. Although F. A. and his father both made their careers as industrialists, F. A. never forgot his rural origins, and Stan Hywet's landscape reflects that fact. The entrance drive still winds through an apple orchard, though the original trees have been replaced by young trees of the same varieties. The garden area north of the Manor House supplied large numbers of vegetables grown in the garden plots between lanes of apple, peach, pear, and cherry trees. At the north end was the grape arbor, and on the garden's east side were double lanes of currant bushes stretching almost the whole length of the garden area. To the west was another orchard of peaches and apples, and beyond that a field of hay for the estate's workhorses. North of the railroad tracks, corn and potatoes were grown in commercial quantities. Farther north, in the Cuyahoga Valley, F. A. owned hundreds of acres which he rented to individual farmers.

Despite, or perhaps because of, the stresses of the Great Depression, the 1930s were also a time of spiritual renewal for many people. In 1933, a number of leaders of the Oxford Group, a movement aimed at helping individuals recapture the basics of first-century Christian teachings, held a series of meetings in Akron. Henrietta, as well as her mother-in-law, Gertrude, went to several of these meetings and were quite inspired by their spiritu-

al message. Henrietta persevered in an earnest effort to live this "new-old" spiritual discipline and to help others, including her children, to do likewise.

Our father, Fred, was an outdoorsman—a hunter, fisherman, bird-watcher, and serious student of nature. One Sunday morning in May, when I was about eight years old, he took my six-year-old sister Mary and me on a long walk in the woods north of Stan Hywet. It was a perfect spring morning. He told us the names of the different kinds of plants and trees as we went along, showed us skunk cabbage, dogwoods in blossom, violets, trillium, and other wildflowers. In a brook, he found for us stones with fossil seashells. It was a magical, eye-opening experience. It left me with a new, conscious love of nature, which was to grow as the years went by. It was only many years later, however, that I came to realize that the natural landscape around Stan Hywet was in great part the result of an inspired design by a renowned landscape architect, Warren H. Manning.

F. A. and Gertrude both felt strongly about the importance of the natural world to one's physical and spiritual well-being. They also were in accord as to the importance of the design element in Stan Hywet's landscape. However, they sometimes had minor differences as to the details. Mr. Bachtel, the grounds superintendent, once told me the following story: Gertrude had ordered him to cut down some large trees that had grown so they were blocking one of the vistas of the distant Cuyahoga Valley. When he noticed the felled trees, F. A. called Mr. Bachtel to his office, where the following conversation took place:

F. A.: "Bachtel, I see you have cut down some trees in the woods."

MR. B.: "Yes, sir."

F. A.: "You know how long it takes to grow a tree? 100 years!"

MR. B.: "Yes, sir."

F. A.: "Well, how do you explain this?"

MR. B.: "Mrs. Seiberling directed me to."

F. A.: "Oh! Very well."

End of conversation.

Before I was even in my teens, I started to appreciate the fine

collection of books in Stan Hywet's library. Many an afternoon, when I could have been doing my homework, I would find myself browsing through an encyclopedia or, curled up in the library, reading some adventure story. There was also a great collection of stereopticon slides of the Civil War and World War I, from which I learned at an early age about the horror of war. Our grandparents subscribed to many different kinds of magazines and kept the latest issues on a large table in the Great Hall. I checked them frequently and became a regular reader of *National Geographic, Popular Mechanics, Scientific American,* and others that stretched my mind and broadened my horizons.

Given our mother's and grandmother's interest in music, it is not surprising that we children developed an early interest in it, too. One unusual source was the pipe organ in the Music Room. Behind the organ were shelves of player rolls of classical music. By our early teens, we had learned how to insert the rolls in the organ and get it to play the pieces recorded on the rolls.

Our youngest uncle, Franklin, who was only about ten years older than I was, had a good collection of phonograph records of both jazz and classical music. He lived at the "big house" in the 1930s and generously let me come over and play them whenever I wished. He also had a short-wave ham radio broadcasting station in a back room on the third floor, where I spent hours listening to him converse with operators in other parts of the country. He and I often had wide-ranging discussions on a variety of subjects, from music to international affairs. My sisters used to follow Uncle Franklin around on Stan Hywet's golf course, getting pointers on the game and learning the themes from Bach and Mozart that he whistled as he played golf.

Our grandmother was not only an artist and singer but also a promoter and organizer for the arts. She was a founder of the Akron Garden Club, the Tuesday Musical Club, and the Akron Civic Opera Company, which presented several operas in the 1920s and 1930s. She occasionally invited them to use Stan Hywet for meetings and other activities. We children were often unseen spectators at these events. I remember, in particular, some of us sitting in the Music Room balcony listening to rehearsals of Mascagni's opera, *Cavalleria Rusticana.* Afterwards we went out-

doors and played out our own version of the opera, singing bits of the arias and acting out some of the roles.

Except when they were out of town, F. A. and Gertrude usually had Sunday dinner in the large dining room, to which were invited their children and school-age grandchildren. Although the grandchildren did not usually participate in the grown-ups' lively conversations, we listened and learned about the family and the world.

The Manor House continued as the site of weekly and seasonal family festivities until the death of my grandmother in 1946. The funeral service at Stan Hywet was a fitting tribute to her spirit. Her casket lay in the West Porch surrounded by masses of flowers. Her paintings were displayed in every room, from the entrance hall to the Music Room, where the service took place. The room was filled to overflowing. A string quartet in the Music Room balcony softly played the slow movement of Beethoven's "First Rasumovsky" quartet and other chamber music. The family sat upstairs in Gertrude's Morning Room, with the door to the balcony open so we could hear the service.

His wife's death was a profound shock to our beloved grandfather, F. A., who was already in his eighty-sixth year. In an effort to console him, my mother, my sister Mary, and I spent much time with him in the next few months, conversing, playing bridge, and in other ways trying to take his mind off his bereavement. We grandchildren had always looked up to him as a wise, kind, upright, and generous person, but also as an authority figure. Now we began to enjoy more and more his penetrating mind and his sense of humor.

One evening, we were having dinner with him in the Breakfast Room. Also with us was Mrs. Anna Boroff, a family friend. Grandfather just sat silently eating his dinner. Finally I said to him, "Grandfather, tell us about the time you went to Paris as a young man."

"Well," he said, "my father sent me to Europe to line up a distributor for our farm machinery business. From England, I crossed the Channel to Calais, then took the night train to Paris. The next morning, I found myself walking down the Champs-Elysées—a broad street, low, graceful buildings—and all the

shop girls were walking to work—some of them good lookers, too."

Mrs. Boroff interrupted, "Mr. Seiberling, are those French women as good-looking when they are older as they are when they are young?"

With a twinkle in his eye, F. A. responded, "I didn't stay long enough to find out."

By this time, of course, we were well acquainted with the salient facts of our grandfather's long and spectacular career, and we had a sense of the nearly legendary respect in which he was held in the Akron community and the rubber industry. This was derived not only from his accomplishment in building Goodyear from nothing to the country's largest rubber company, but also from his civic leadership, especially after some Wall Street bankers forced him out as head of Goodyear during the 1920–21 economic depression. As Goodyear's largest stockholder, he could have protected his interest by asking a court to put the company in receivership. He declined to do so, and later explained why in a letter to a former associate: "The interests of the stockholders alone would have dictated a receivership, but here were we, the biggest factor in the community, with our banks loaded with Goodyear collateral, all of our boys [that is, employees] having borrowed to their limit, and a receivership under the circumstances would have brought catastrophe to our town, busted half the banks and mentally wrecked many of our people. I did not propose to have them pin that calamity onto me, no matter what the personal sacrifice might be."

F. A. went on to say, in the same letter: "Stripped of money and power, burdened with debt, my outlook might seem disheartening, but it is not so. The greatest pleasure I had in life was starting at the scratch line with Goodyear, without a dollar, and all the difficulties that were encountered that had to be surmounted. The pleasure of such a battle I am going to have all over again in the effort to construct something from nothing."*

And so, in his sixty-second year, F. A. started over again, suc-

*F. A. Seiberling to Mr. Arthur Kudner, Akron, Ohio, 14 June 1921, Manuscript Collection, Stan Hywet Hall and Gardens.

cessfully launching Seiberling Rubber Company and heading it for the next twenty-eight years. Though the new company never even approached the size of Goodyear, F. A. was universally respected as the "grand old man" of the rubber industry.

F. A. was also admired for his leadership in other fields. Among other things, he was in the forefront of urban planning. He believed that a successful company should help its employees and the community beyond simply providing jobs, important though that is. Living up to this philosophy, F. A. purchased and developed land to provide affordable housing for his factory workers and an upscale residential area for company executives.

F. A.'s lifelong interest in serving people and his strong belief in conservation of nature were joined in his leadership for expanding outdoor recreation opportunities for the entire metropolitan area. In the early 1920s, even as he was struggling to build a new company, F. A. accepted appointment to the governing board of the newly created metropolitan park district, with the aim of creating a countywide system of large rural parks. By a remarkable "coincidence," the board hired Warren Manning to survey the park potential of the county. The firm's report, issued in 1925, found that the Cuyahoga Valley, north of Akron, was the most important scenic area in the county, and recommended that it be preserved from end to end and rim to rim as a rural park. To do that would have required that the park district acquire thousands of acres of land at a cost beyond its potential ability to raise public funds. Instead, it focused on the creation of smaller parks in key locations.

F. A. did not wait for tax money to start flowing to get the new metroparks system started. He gave several hundred acres of his own land, north of Stan Hywet's core landscape, to initiate Sand Run Reservation, the first unit of the new system. It is still the most popular park in the system, with over a million users per year.

Nevertheless, the Manning report remained a sound recommendation. Nearly fifty years later when I was the U.S. congressman representing the Akron area, I led a successful campaign to persuade Congress to enact legislation, in 1974, creating the thirty-three-thousand-acre Cuyahoga Valley National Recreation

Area. This legislation incorporated the basic concepts laid out in the 1925 Manning report. I think F. A. would have been pleased.

The death of F. A. in August 1955, at the age of ninety-five, left his children and grandchildren, the heirs of Stan Hywet, with a dilemma. None of us could afford to keep it as a home, but if we were to sell the property and the contents of the house, we would be dismembering a great work of art. What were we to do? That is the rest of the Stan Hywet story in this tribute to a family and the large house they made a home.

PREFACE

When I consider what some books have done for the world, and what they are doing, how they keep up our hopes, awaken new courage and faith, soothe pain, give an ideal life to those whose hours are cold and hard, bind together distant ages and foreign lands, create new worlds of beauty, bring down truth from heaven; I give eternal blessings for this gift, and thank God for books.

—*James Freeman Clarke*

Being involved with the creation of this book was a delightful and rewarding experience. Its inspirational images give joy, its words tell the story of a remarkable family, and its pages document a treasured American landmark. The impetus to create this book was the natural progression of the restoration and stewardship endeavors which have been taking place ever since the Seiberling family originally donated Stan Hywet Hall and Gardens to the public in 1957.

Although I never had the opportunity to know F. A. or Gertrude Seiberling, I admire them both from the cherished memories their family members have shared and the documented accomplishments of their lives. I know, for example, that they loved and supported the arts and music: Stan Hywet is filled with the treasures they collected from around the world and boasts one of the finest music rooms ever created. Their formal gardens and woodlands were also precious to them and today are considered world class. I know too that they took very seriously their leadership role in the community and made major contributions to the quality of life in the Akron area. Stan Hywet takes pride in striving to continue this leadership tradition.

Most of all, I know that the Seiberlings took special pride in

sharing Stan Hywet with others. *"Non Nobis Solum,"* NOT FOR US ALONE, was the family motto, which remains engraved above the entrance to the Manor House. From the first day the estate was opened, it was often host to family and friends; everyone from famous artists and leaders of the day to neighborhood children were welcome.

Guests are still a very important part of Stan Hywet. Each guest keeps alive not only the pleasure F. A. and Gertrude took in entertaining, but also the ideals of the entrepreneurial spirit represented by a working estate that sustains and benefits the community. It is your support that allows Stan Hywet to remain self-sufficient and a leader in historic preservation.

I am certain that the Seiberlings would be pleased that so many people continue to visit and appreciate their home and gardens. As you tour the estate through this book, I hope that you enjoy yourself as thoroughly as all the other honored guests who have preceded you and that you are inspired by the images you see and the words you read.

Welcome to Stan Hywet Hall and Gardens.

Harry P. Lynch
President and CEO

ACKNOWLEDGMENTS

This is an attempt to recognize all those who contributed to the creation of this book, an "attempt" because writing a few words about all the effort and hours individuals put into its production seems minor; however, it would be unthinkable not to try, for without their support and assistance it never would have become a reality.

First, I would like to acknowledge and thank Ian Adams. Ian met with me when this book was just an idea. He pointed me in all the right directions and helped me bring into focus what we wanted to accomplish with this work. His skill and talent is evident, demonstrated throughout this book with his inspirational images of Stan Hywet. I was not the only one who observed and appreciated what effort it took for Ian to create these images.

Soon after my first meeting with Ian, I had the opportunity to discuss the idea of this book with Elton Glaser from The University of Akron Press. Elton provided not only tremendous enthusiasm for the concept I presented, but also took on the responsibility of addressing the details necessary to turn this concept into reality. His experience and skilled leadership turned distinctive images and inspiring written words into this exceptional book.

Barney Taxel is very familiar with Stan Hywet because of all the time he spent waiting for the right light and, in some cases, creating the right light for his extraordinary Manor House images. His artistry and skill is evident in all of his images, but for me his photographs of the Manor House interiors exposed details I had never before seen. Additionally, his experience with book design has helped greatly with the clarity of this work.

Steve Love's words complement the images perfectly. He spent untold hours researching the Stan Hywet facts and separating them from fiction. He is a talented writer with special skill at weaving an engaging story from bits and pieces of researched facts and family memories.

Particular thanks and recognition must go to John Seiberling who wrote the very special foreword. When I met with John to ask him if he would consider working on this project, he was a little hesitant, but fortunately he agreed. His work revealed the personal side of Stan Hywet, which can only be told by someone who actually experienced living on the estate. John's insights truly make this book distinctive.

Few things would be accomplished in our office without the guiding hand of Patty Deurlein. Her dedication to Stan Hywet and this project was evident in the meticulous attention to detail she demonstrated in administering and coordinating this undertaking.

Margaret Tramontine, Mark Heppner, Dave Desimone, and Vic Fleischer, as well as other collections staff, frequently administered to the needs of the photographers, writer, and publisher. The quality of this book would not be what it is without their efforts.

The rest of the committee which served to review photographs and offer design insight included Gary Hartman, Laura Strauss, Marilyn Vernyi, Samantha Fryberger, Carl Ruprecht, Chris Lowther, Tanya Stamp, and Susan Carano. Their contributions were both in time and valuable perspective. Finally, tremendous gratitude and appreciation must be given to the dedicated staff and volunteers who on a daily basis make Stan Hywet the extraordinary place that it has become.

Harry P. Lynch
President and CEO

STAN HYWET HALL & GARDENS

THE STORY OF
STAN HYWET HALL

On two days in 1955, the heirs of Frank A. and Gertrude P. Seiberling confronted a large but everyday problem concerning money: There wasn't enough of it. It was an odd problem for the scions of one of the great industrial families of Akron. But in resolving it, the Seiberlings proved themselves a family willing to place love above money, community ahead of self-interest.

This should have come as no surprise. These Seiberlings were, after all, the descendants, the children and grandchildren, of F. A. and Gertrude Seiberling. In Akron, the former "Rubber Capital of the World," there may have been names that came before the Seiberlings and names that stood taller to the outside world. Dr. Benjamin Franklin Goodrich brought the rubber industry to Akron, in 1870, and Harvey S. Firestone achieved a profile higher than the statue of him that still stands off South Main Street in south Akron. But it was the Seiberlings who left to the community Stan Hywet Hall and Gardens, the finest, most lasting gift to Akron of all the rubber barons.

It was not a foregone conclusion that the house built by the Goodyear Tire and Rubber Company and sustained by the Seiberling Rubber Company would be standing today in the twenty-first century, open to visitors from around the world. Other majestic homes of other important Akron industrialists—Firestone's Harbel Manor, for example, and the Barberton mansion of O. C. Barber, owner of Diamond Rubber but better known as the "Match King" for his Diamond Match Company—have disappeared in time, unsupportable by family, unsustained by the Akron community.

Stan Hywet is different, unique among the mansions.

On Tuesday, August 16, 1955, the Seiberlings held a private service and buried the family patriarch, F. A. Seiberling, in Glendale Cemetery, final resting place of Akron's elite. F. A. was ninety-five. He had given the family the strength and wisdom to support the legacy he left but could not fund with the endowment he had intended.

Two years earlier, J. Penfield Seiberling, F. A.'s son and successor as president of Seiberling Rubber, had written to his sister, Virginia (Ginny), and her husband, Jack Handy, concerning Stan Hywet Hall, the Seiberlings' wondrous sixty-five-room home. Penny, as everyone called him, made no secret that this American Country House, built between 1912 and 1915, was "the greatest single problem that confronts us."

"It is," Penny reminded the Handys, "a magnificent structure but at the same time, by that very fact, a white elephant."

Since a family meeting at Thanksgiving in 1947, the Seiberling heirs had been searching for a consensus about this great white elephant that would be theirs. As in many families, procrastination prevailed. Gertrude Seiberling had died January 8, 1946, but F. A. was still at Stan Hywet, this little big man of five feet four inches, a giant among American industrialists in a tough little boy's body.

So the Seiberlings put off the moment of decision by exploring their many options. Everyone had a suggestion. The child welfare board suggested Stan Hywet would be a perfect children's home—the F. A. Seiberling Memorial Home for Children. Schools, hospitals, homes for the aged. There was no end to the ideas.

Perhaps the strangest but most appealing idea for a cash-strapped family with business challenges to face came from Fairlawn Country Club. Someone suggested to Penny that the club would be willing to swap its property, which could be turned into prime lots in the hottest real estate area of town. Fairlawn Country Club would convert Stan Hywet into a clubhouse and the surrounding acres, as many as six hundred, into a premiere golf course.

Penny, writing to Ginny and Jack Handy, acknowledged that

it would be a shocking end to F. A. and Gertrude's dream of leaving a center of art, culture, and community. "But," Penny told them, "I can see little possibility of [such a center] becoming a reality."

Franklin, the Seiberling's youngest son, had earned a doctorate in art, teaching first at The Ohio State University and then the University of Iowa. With that background, he had been exploring the possibility of donating Stan Hywet Hall to the Ohio State Archaeological and Historical Society. He was not optimistic. Everyone in the arts community responded in the same way: Love to have it. Can't afford to accept it.

The August 1955 meeting of the family began against that backdrop in Stan Hywet's dining room. Some forty family members crowded around the table, with Penny seated at the head. Near the conclusion of the luncheon, John Frederick (Fred) Seiberling, eldest of the siblings, rose to share the thoughts that had filled his mind during the long drive to Stan Hywet from Cedar Lodge, the family's summer home in Hessel, Michigan. As he listened to the radio in the car, station after station had broadcast the fact of F. A. Seiberling's death, making him think about just what his parents had meant to Akron and about their dream for Stan Hywet's future.

When Fred sat down, Irene Seiberling Harrison seized the moment, for no Seiberling felt more strongly about Stan Hywet. She had been there from Stan Hywet's inception, traveling to Europe in 1912 with her mother and father and architect Charles Schneider. With the help of Sir Walter Tyndale, an English aristocratic friend of a friend, they had gained entrée to and been inspired by some of England's finest homes. They brought back to America ideas that would turn Stan Hywet Hall into a unique early twentieth-century American Country House, in which Irene lived until her marriage in 1923.

Now, at this meeting, it was as if the torch had been passed, to be borne by another generation or two of Seiberlings. The meeting was the last large gathering of Seiberlings at Stan Hywet. The Seiberlings talked about Casa Loma in Toronto and about the Oglebay Estate near Wheeling, West Virginia. They had an obligation, and Irene had made her father a promise. When he

had expressed consternation about his inability to endow Stan Hywet's future, she had promised she would find a way to keep that dream alive.

"Think what it will mean," Willard wrote to sister Ginny, "if in the twenty-fifth century tourists can go through Stan Hywet and see how the Seiberling family lived 500 years ago!" He signed the letter: "Yours for family loyalty."

That thought carried into a September 1955 meeting that went beyond the family and into the community. The Seiberlings invited to Stan Hywet Hall the leaders of practically every organization in Akron, as well as other leading citizens. They hoped for a turnout of fifty. Seventy-five showed up for what became a sneak preview of the guided tours offered today. Irene had coached a group of guides to take small parties through the house. Everyone invited had been in the house, some many times. They knew the first-floor rooms. They had not, however, seen the second-floor living quarters or the basement or the third floor, places that might spark ideas of community uses.

Fred and Franklin Seiberling, along with their cousin, Robert Pflueger, opened the meeting to ideas from the community members. One after another of Akron's movers and shakers lent support for the guiding philosophy that F. A. and Gertrude Seiberling had chiseled into the stone of Stan Hywet: *Non Nobis Solum*—Not for Us Alone. Sentiment, however, doesn't pay the heating bills.

"I don't know whatever is going to happen to this place," F. A. had told Irene.

A small woman of great will, Irene pledged to her father that she would see that Stan Hywet Hall became the community treasure he and Gertrude had envisioned.

"I'm going to outlive you," Irene said, "and I'll stand by and see that it is done."

The truth is, Stan Hywet Hall was nearly the death of itself. Near the end of his life, F. A. Seiberling made a startling admission, though not without ambivalence: "Because of the pleasure the house gave all of us, it is difficult for me to admit now that I regret building it."

The costs had spiraled out of control as F. A. tried to make Stan Hywet a home that would satisfy his family's every desire:

The Plunge—or pool, as it is more commonly known today—which the boys really wanted, and everyone enjoyed. The Music Room for Gertrude and Irene. The small touches that grew into big expenses. Had he not overcommitted in the building of Stan Hywet and, at the same time, in seeing that his workers had their own piece of the homeowner's dream across town in Goodyear Heights, F. A. might have been in a better position to overcome the 1921 financial disaster that forced him out of Goodyear, the company he lovingly called his "baby."

In 1955, the Seiberling heirs had not left to chance what they wanted to occur at the Stan Hywet meeting with community leaders. They had arranged that, at the end of discussion about the home's future, someone would make a motion to establish a committee that would study the creation of a Stan Hywet Hall Foundation. The plant, however, proved to be unnecessary.

Dr. Norman Auburn, president of The University of Akron, made a similar motion on his own. The committee was formed. Akron's Big Four rubber companies—Goodyear, Firestone, B. F. Goodrich, and General—and others underwrote a financial study. The result was daunting. A $1-million endowment would be required for Stan Hywet's second life. In addition, a $50,000 parking lot would be required before the doors could be opened to the public. Corporate Akron, primarily men who thought with heads rather than hearts, said Stan Hywet couldn't be saved.

The women said otherwise.

Irene Seiberling Harrison and a legion of Akron women turned the saving of Stan Hywet into a crusade. They needed a million dollars but went about getting it one dollar at a time. If F. A. Seiberling could sit in his kitchen in the old family home on East Market Street and, with Gertrude, sign over his Goodyear stock as collateral to finance the building of Goodyear Heights for his workers; if F. A. could pay Stan Hywet's landscape architect, Warren H. Manning of Boston, to lay out Goodyear Heights and Fairlawn Heights, a west Akron development where many of the Goodyear executives bought homes; if F. A. could worry practically on his deathbed about the future of Stan Hywet, then these women could do what the men would not.

They could refuse to give up on Stan Hywet Hall.

Before there was Stan Hywet, there was the land that would shape it. When he was a boy, F. A. Seiberling had tramped these fields and woods outside of Akron, hunting this area where sandstone had been quarried. Even then, the dramatic views of the Cuyahoga Valley, natural vistas that spread before a person like paintings, would stop young Frank in his tracks. He never forgot them.

So, in 1910, when he began to take his family on buggy rides outside of Akron in search of the right place to build a country house, the land on which Stan Hywet Hall stands drew F. A. back to it. He hooked up the horses, loaded the family into a horse-drawn wagon with fringe around the top, and headed down country lanes and through fields. One of those lanes became Garman Road, bordering the Seiberling estate. F. A. may have known the site he wanted, but he used the experience as an exercise in decision-making for his children. After a day of looking at various sites, the family would return to its house on East Market Street and convene a family meeting.

"Now children," F. A. would say, "how did you like the place we visited today?"

They loved the site of Stan Hywet when they first saw it. It was autumn, and the trees raged with colors. Crimsons. Golds. Browns. The land was thick with chestnut trees, the ground blanketed with chestnuts. The children gathered the chestnuts by the armful, and the land's first impression became a lasting one.

"He always tried to make us think," said Irene. "He didn't do things carelessly, just to pass the time."

When the land in the area of the old sandstone quarry had been chosen, F. A. approached its acquisition with equal care. He bought sixty acres through an agent who protected F. A.'s identity. Then he bought another eighteen acres. He kept at this until he had a thousand acres. But Akron was a small place in those days. It had a population of only sixty-nine thousand in 1910. During the next decade, in large part because of the success of F. A. and Charlie Seiberling's Goodyear Tire and Rubber Company, Akron would become the fastest growing city in the country, jumping in population to 208,435. In these circumstances, perhaps F. A.

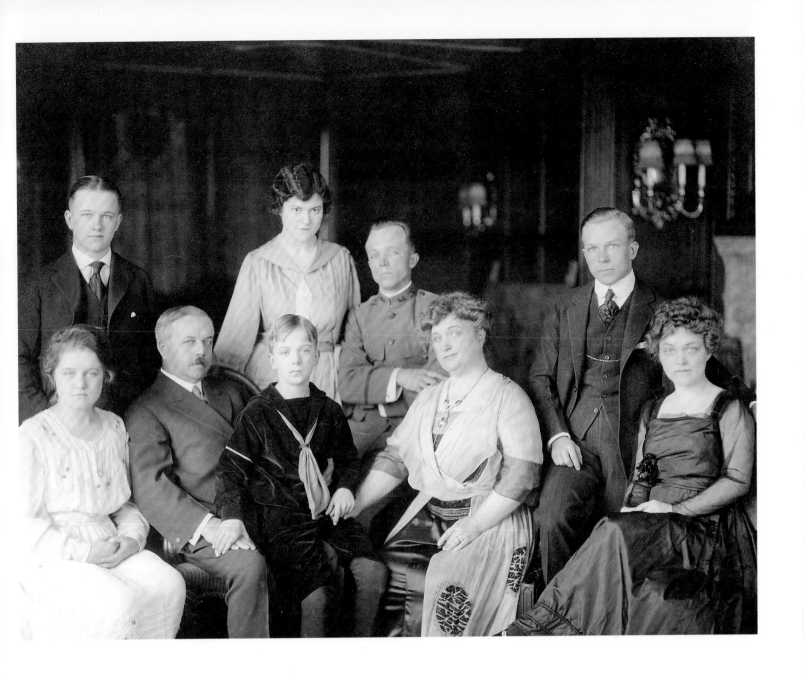

would have been able to keep secret his identity as the purchaser of the land. As it was, word got around and bargaining became more difficult.

The Carriage House occupies a part of the final one-and-a-half acres that F. A. needed to complete his land puzzle and begin building his home. F. A. thought a fair price would be $1,200 to $1,500. The landowner had other thoughts. He knew who wanted his land and why, and that F. A. Seiberling had the money to pay a premium price. The $9,000 that F. A. ended up handing over for the final piece of land should have been an omen. Before Stan Hywet was completed, the cost would escalate beyond F. A.'s wildest nightmare. Still, he proceeded, heart in one hand, wallet in the other.

The Seiberling Family, 1917. Standing (left to right): Penfield, Henrietta, Fred, Willard. Seated (left to right): Virginia, F. A. Seiberling, Franklin, Gertrude, Irene.

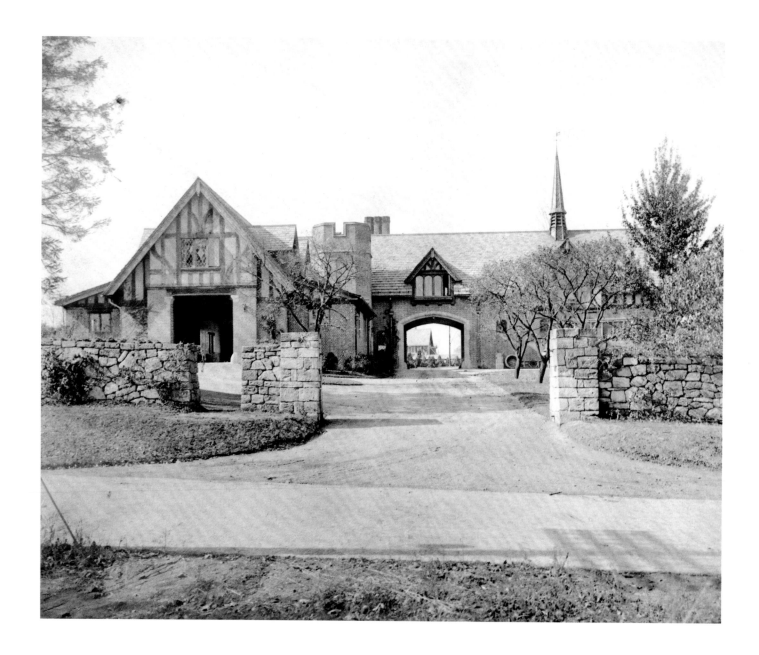

Carriage House, ca.1915

F. A. had proposed building a home away from the increasing din of Market Street. Soon after his father, John F., a noted industrialist and inventor in his own right, died in 1903, F. A. went to his mother, Catherine, and suggested that he build a home large enough for his family and for her. She could move in and continue her role as Seiberling matriarch. Catherine Seiberling would not hear of it. She loved her East Market Street home. She made F. A. promise that there would be no changes, that he and Gertrude and their growing family would stay in their rented house next door until Catherine was gone. F. A. could never say no to his mother or, for that matter, to any member of his family.

Family was important. Catherine Seiberling had established that fact by following her family's Germanic traditions. On Sunday nights, everyone gathered at Grandmother Seiberling's three-

story home with the cupola on top. The grandchildren, such as Irene, would find their way into the kitchen, where Catherine would be sitting in a rocking chair, a long-handled spoon in hand, stirring apple butter. When it had thickened, the children spread the apple butter on piping-hot muffins. After dinner, while the children played, the older Seiberlings adjourned to the library. They shut the door and whiled away the night discussing local and national affairs.

It was this atmosphere of family that F. A. and Gertrude Seiberling wanted to recreate when they moved ahead with their plans for a home of their own following Catherine Seiberling's death in 1911. In the preceding years, Gertrude had prepared herself to be the cultural force that she would become not only within Stan Hywet's walls but also in her city and nation. She attended Buchtel College, now The University of Akron, where she studied such things as landscape architecture, interior decorating, architecture, and horticulture. Gertrude knew she would have to deal with experts in these disciplines, and she wanted to be prepared to make her house the home she always had wanted.

The Seiberlings conducted an architectural competition, receiving ideas from six or eight firms, from Cleveland to New York to Boston. They chose George B. Post and Sons of New York and worked with Charles S. Schneider, who ran the firm's Cleveland office. While the Seiberlings did not limit the proposals, their guiding principles, what set them apart from other families, became obvious.

They didn't want a home that was too grand and fancy (no French palaces), too institutional or resort-looking (no southern colonials), or too walled off and foreboding (no Norman castles). What they wanted was something large yet informal. They decided on Tudor Revival, and F. A. Seiberling put in writing to Schneider what he wanted to spend. On March 8, 1912, Schneider responded in kind, acknowledging that F. A. wanted to build a home, excluding land costs, interior decoration and furnishings, that would not exceed $150,000.

That figure might have been a joke had the actual cost of Stan Hywet not had such serious consequences for the Seiberlings for the rest of their lives.

In 1912, Schneider accompanied the Seiberlings—F. A., Gertrude, and Irene—on a visit to England, where Sir Walter Tyndale arranged to show them not only Tudor houses open to the public but also some that were not. The trip was for business—the business of buying rubber for F. A., and the business of collecting ideas for the Seiberling house for Gertrude, Irene, and their architect.

As much as Gertrude had studied and prepared, as good as Schneider and the other professionals who designed Stan Hywet were, Irene and her mother always believed that this American Country House turned out as beautifully as it did because of divine intervention. The assistance they received from Tyndale is one example of this.

Sir Walter Tyndale, illustrator of books on the manors of Sussex and Wessex, didn't know the Seiberlings. Nor did he know the friends of the Seiberlings, the William Charles Bairds, who owned two of his books and decided they would write to him and ask if Tyndale would shepherd the Seiberlings through the great houses of England.

F. A. thought this a terribly presumptuous proposal. "I have heard of many fantastic ideas of Americans, but this is one of the biggest," F. A. said. "How would Sir Walter Tyndale, who has never met our friends and doesn't know us, find any interest or desire to take these loudmouthed, shouting Americans . . . around his priceless, wonderful soil?"

Yet Tyndale did. He met the family at the dock in Plymouth, England, and for ten days he opened doors that perhaps no one else could have opened. The Seiberlings and Schneider, sketch pad in hand, accompanied Tyndale to Compton Wynyates in Warwickshire, to Ockwells Manor in Berkshire, to Haddon Hall in Derbyshire, and to other homes from which Schneider did not so much copy as draw design inspiration. For instance, the entrance of Stan Hywet has a number of similarities with that of Compton Wynyates, although closer study, according to noted art historian Franklin A. Seiberling Jr., reveals many differences, some subtle, some obvious.

"By directly comparing the main entrance of Stan Hywet with that at Compton Wynyates," Franklin wrote in a pamphlet

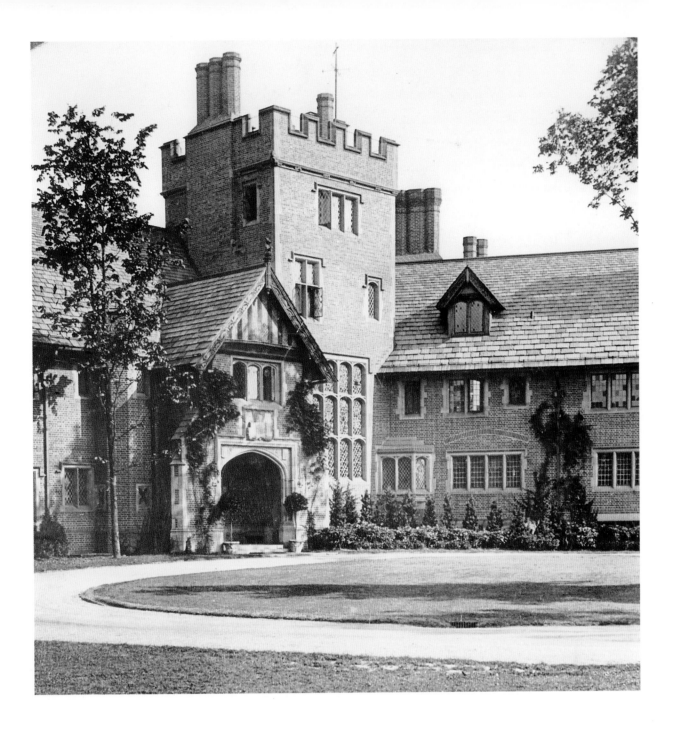

titled "What Is the Tudor Period and Style?," "we may see what
Schneider meant by preferring 'not to take things too straight.'"
He didn't mean just the angles taken by the north and south axes.
Above the similar wide front openings, with their welcoming
porches, arches in stone with their crested center areas and win-
dows, is the subtle difference to the layman, Stan Hywet's gable
roof with open timber construction and Compton Wynyates hor-
izontal parapet with toothy contour.

A more obvious difference is that Compton Wynyates, like
many Tudor mansions, was built around an open-air court. There
is no such inner court in Stan Hywet Hall. Its Great Hall opens

*Main Entrance, Manor
House, 1916*

onto the West Terrace and a compelling vista of the Cuyahoga Valley. Besides the fact that Schneider did not come home with a cookie-cutter replica of Compton Wynyates or any other English mansion, the Seiberlings refused to try to buy style. Rumors abounded that the family had imported entire rooms from English mansions and built Stan Hywet to fit them. In fact, only the interior wall paneling of the Master Bedroom, sometimes referred to as "Mrs. Seiberling's Bedroom," came from abroad. The rest of the woodwork was hewn, carved, and fitted by American craftsmen whose work, Franklin concluded years later upon revisiting the places in England, was equal to if not better than the European splendor.

Still, when the Seiberlings came upon an English home being torn down and razed, they saved the rich wood paneling for the Master Bedroom, including the window that overlooked a courtyard. Gertrude Seiberling told Schneider to leave the window intact, and she wasn't just trying to be artistically faithful to the original room. She had the window positioned so that it would be high on a wall in the Great Hall. From it, she could look out and keep an eye on the children, all from the privacy of her bedroom. The window became known as the chaperone's window.

Judicious in their acquisitions, the Seiberlings nonetheless brought home from Europe two prizes purchased more with personality than money. Both are items of rare beauty: the stained glass windows in the front of the house, for which the Seiberlings received the right to have replicas made, and the harpsichord in the music room.

Over the years, myths have grown up around Stan Hywet Hall, haunting the truth like ghosts, unseen yet present. Today's professional staff gives a "Fact or Fiction" presentation to right the record. The irony is, the myth is overkill. The truth is fascinating enough, as with the harpsichord, which became one of Gertrude's favorite possessions.

Myth has it that Handel once played this harpsichord. It would have been an otherworldly achievement, since Handel died in 1759, fourteen years before Robert Faulkner made the instrument. But myths grow out of mistakes, most of them unintentional. F. A. even cultivated this myth. He used to tell people

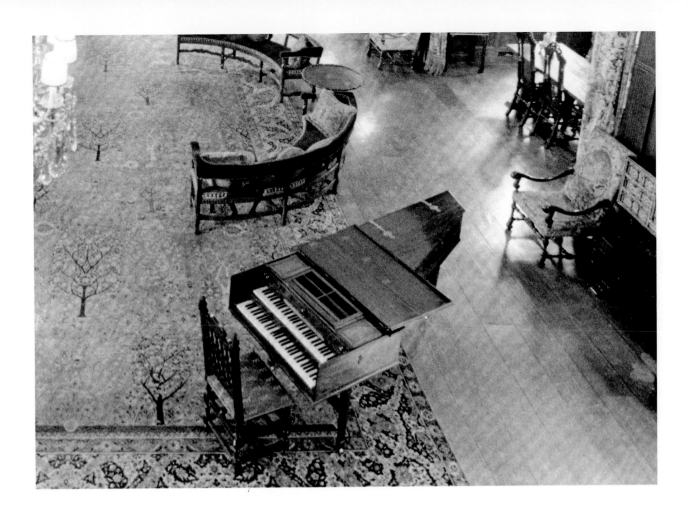

about how he came to buy Handel's harpsichord for Gertrude. The owner may have been wrong, but the story hits the right note: It sounds like the Seiberlings.

What is true is that Joseph Haydn may have played the harpsichord which F. A. paid for in dollars but which Gertrude purchased with her lovely contralto voice.

The Seiberlings discovered the harpsichord during their visit to Ockwells Manor. It was a prized piece of Lady Barrie, wife of Sir Edward Barrie. F. A. apparently told Sir Edward about Gertrude's beautiful voice, one which took her in 1910 to the White House to sing for President William Howard Taft. F. A. thought the harpsichord would be the perfect match for Gertrude's voice and would complete the Music Room as nothing else. Sir Edward could appreciate F. A.'s enthusiasm because the harpsichord belonged to Lady Barrie and was a family heirloom.

As the men talked, Gertrude joined them and began to sing a solo from Handel's *Messiah*, which could explain whence the myth sprang.

1773 Harpsichord by Faulkner of London, Music Room

"When she had finished," said Irene, who was present and would retell the story over the years, "tears were rolling down Sir Edward's cheeks."

"Mrs. Seiberling," Sir Edward said, "I've never heard that sung as you sang it. I realize you have the same reverence and respect for Handel that we have. I would be content to let this harpsichord go into your possession if Lady Barrie is willing."

How could Lady Barrie say no?

F. A., as was his wont, paid twice the price that Lady Barrie asked. Unlike some of his expenditures, however, he never regretted this one. "Because of some queer, inexplicable satisfaction the instrument gave me," F. A. said, "I always felt I got a great bargain."

If Gertrude's voice made possible the purchase of the harpsichord, the Seiberlings' sincerity of mission led Sir Edward to do something he had never done before. He granted the Seiberlings permission to copy eight of the home's eighteen windows that dated from 1455–60. The stained and leaded glass heraldic crests were made for Stan Hywet by Heinigke and Bowen in New York.

These occasions may have created the misconception that the entirety of Stan Hywet was bought in England, piece by piece, and shipped to Akron to be reassembled. Nothing could be further from the truth. There are 469 windows with 21,455 panes of glass spread throughout Stan Hywet Hall. The Ockwells Manor reproductions amount to a fraction of 1 percent. And all of the glass is American. As American as the glass was, nothing could be more American than the majestic elk's head that is mounted above the fireplace in the Great Hall.

Like so much in Stan Hywet, from the swimming pool to the fine touches in the Music Room, the presence of the elk's head resulted from F. A. Seiberling's desire to make people happy. His sons wanted the Plunge, as the pool was called, so F. A. smiled and took it. Gertrude had her heart set on the expansive Music Room, so F. A. joined the supporting chorus, which included Irene. The purchase of the elk's head is even more telling. It resulted from friendship rather than family.

About the time that F. A. began building Stan Hywet Hall in 1912, Bill Rattle, a mining engineer and a friend of F. A.'s, was

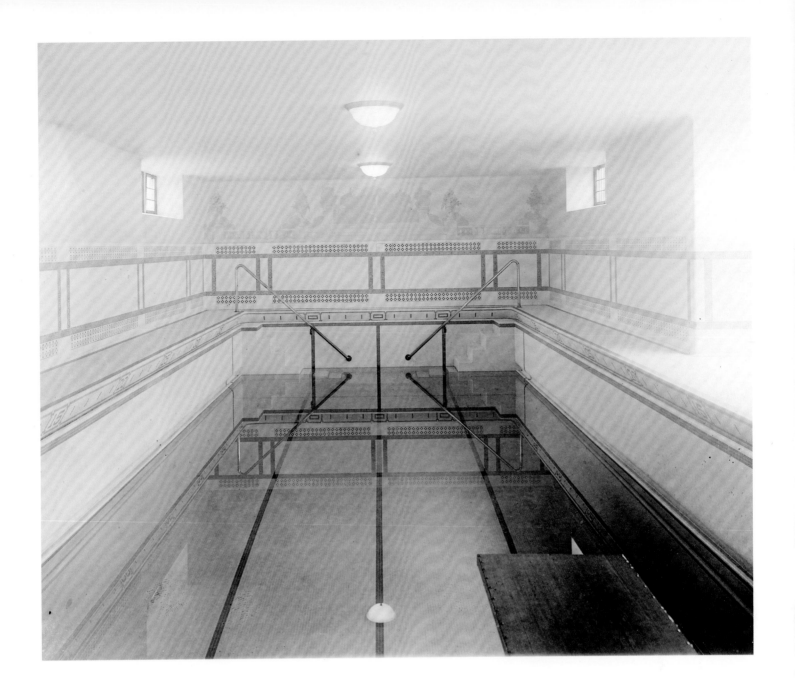

traveling in Montana, where he came upon this great elk's head. He wired F. A.: "Am in touch with an elk's head, the second largest spread in the United States. Smithsonian elk head only one that's wider. Can buy it for you."

F. A. needed an elk's head like he needed a personal set of antlers. His future home was rising slowly. It was years from elk head-ready. But Rattle was a good man and a friend, and he thought he was doing F. A. a favor. So F. A. sent a return wire to Montana, instructing Rattle to buy the elk's head at the suggested price and ship it to Akron.

Initially, F. A. consigned the elk's head to a wall of the Goodyear smoking room. But when Stan Hywet Hall was fin-

Swimming Pool, "The Plunge," under Billiard Room Wing, ca. 1917

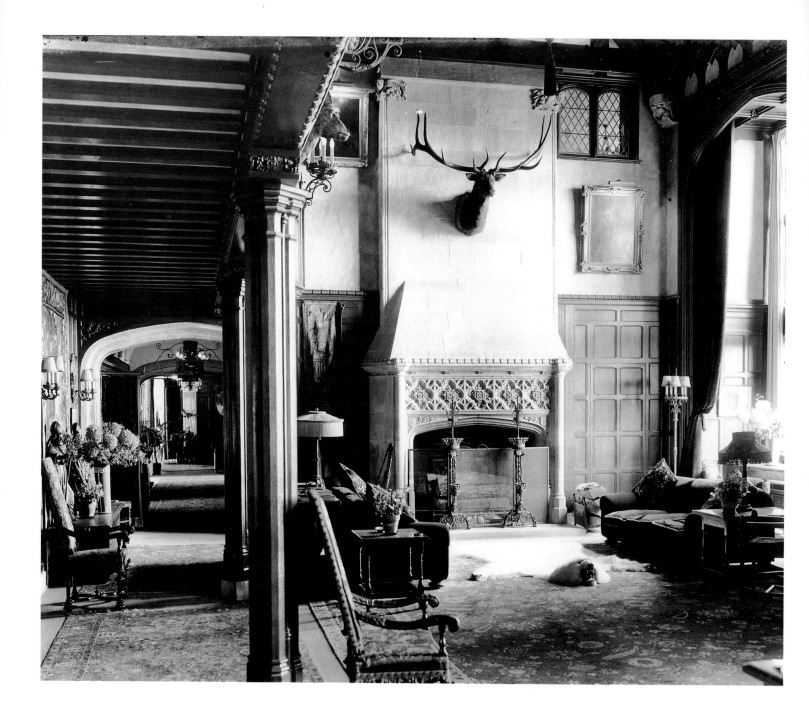

ished, the wall of the Great Hall seemed to demand it be mated with this Montana elk. The more F. A. thought about it, the more he liked the idea.

"To me," he once said, "that huge head, with its vast antlers stretching half across the wide chimney, as it looks down on all that English-born grandeur, is as convincingly American as the Seiberlings themselves."

Some of the Seiberlings, especially F. A., Irene, and Willard, worried that such a big house might come between them, might physically separate the large family that thrived on togetherness

Elk Head, Great Hall,
ca. 1917

and interaction. F. A. tried to reassure Irene by pointing out that the in-house phone system would serve as a link that would make it easier for Irene to locate her brothers or sister at any particular moment. The system worked. But F. A. still had his own reservations.

F. A. would have been satisfied with a smaller house, but if he were going to live in a large one, he would add his own small touches that would make the house a home. For instance, he wanted a fireplace in every primary living area and every bedroom. Of the house's sixty-five rooms, twenty-three have fireplaces. Fireplaces, F. A. thought, warmed more than a room— they created the warm family environment that he sought.

Two of the smaller rooms became F. A.'s favorite haunts: his Office and the Breakfast Room. In the former, he could feel connected to Goodyear by a direct phone line and still be there for family members who needed his counsel or comfort. F. A. used to amaze his grandchildren with an office trick. He would push a button under his desk, and on the opposite wall, the paneling would pop open to reveal a walk-in safe.

It is to F. A.'s Office that two generations of children came not only to be amazed but also to learn the lessons that he believed important. Few of the lessons were more important to F. A. than the sanctity of nature. This farm boy from Norton Township, near Akron, son of a farm machinery inventor, did not lose his awe of and respect for nature when the family moved to the city. His respect for the land and nature is among the reasons he became involved in growing fruit and vegetables, raising poultry, and making Stan Hywet Hall partially self-sufficient.

Franklin, who was seven when the family moved into Stan Hywet, found himself in his father's office one day when he was fifteen. He had received a coveted gift, a BB gun.

"This was a great gift," Franklin said years later. "I went out with it one day, and I saw a cowbird in one of the trees in the allee off the Music Room. I knew the cowbird lays eggs in other birds' nests. I thought this was reprehensible behavior on the part of the cowbird and, therefore, if there were fewer cowbirds, it wouldn't make any difference."

So Franklin plugged a cowbird.

"I thought this was a great thing," Franklin said, "and I took the bird to show it to Father."

F. A. invited Franklin into his office. What he told his teenage son was a lesson that lasted a lifetime.

"That bird," F. A. said, "has as much right to live as any other bird. I don't want you to ever take the life of another creature."

Stan Hywet's gardens and grounds would be a sanctuary, a place of life, not a killing field. Landscape architect Warren H. Manning, as much as anyone, cultivated F. A. Seiberling's naturalist inclination and preserved the land that would become the nearby Sand Run Reservation, F. A.'s seed donation to the Akron metropolitan parks system.

As F. A. considered what manner of landscape architect might complement Schneider in the creation of an integrated indoor-outdoor concept, the name that kept coming up was Manning's. F. A. had inquired who had done the work that he admired elsewhere. Manning's approach coincided with F. A. and Gertrude's belief that the natural world contributed to a person's physical and spiritual well-being.

Manning, from Boston, had had the most respected of teachers—Frederick Law Olmstead, the "father of American landscape gardening." Tall and gracious, a gentle man with contemplative eyes, Manning did not think he knew more than nature. He worked with what he found rather than becoming his own great, solitary force. He got his first glimpse of the Stan Hywet property on June 7, 1911, and his immediate concern was the one hundred acres that surrounded the construction site. Manning was dazzled by what he found. The vistas. The old and young orchards: apple, peach, and plum. The big trees, vines, and shrubs that had grown up around existing farm buildings. Two types of woods: tall old wood with varied shrub and herb undergrowth and younger wood on the more open sloping pasture. And, most impressive of all, the old quarry whence Stan Hywet—"stone quarry" in old English—would draw its name. Manning called it: "The feature that will give the estate its greatest distinction. . . ."

Manning saw it all in his mind's eye: the Japanese Garden, the English Garden, the Great Meadow, the entrance estate drive through the apple orchard, Pleasure Drive looping around the

property. Through the years, Manning would become a presence at Stan Hywet, virtual and physical. He would return to stay with the Seiberlings, to revisit and renew his connection with the land that was the best he ever found.

"He would get up in the morning at the break of day," Irene once said. "He'd have on old tweed pants and heavy tramping shoes. By 5:00 or 5:30, he'd be tramping. He tramped on practically every square yard of the [more than two thousand] acres that father piled up."

Discovery marked Manning's every step.

"You people don't know what treasures you have," Manning told the Seiberlings. "I found ten new wildflowers."

But the Seiberlings did know. More important, they were willing to share their treasures long before Stan Hywet opened its gates and doors to the public. If what he found during his tramp-abouts stunned Manning, the many ways in which the Seiberlings allowed him to put their treasures to use were just as stunning.

F. A. hired Manning to lay out Goodyear Heights, a working man's neighborhood of comfortable homes with fruit trees in every yard, green space, and parks. Next, he set his landscape architect loose on a tract of land in west Akron. That work turned into the upscale Fairlawn Heights, with its adjacent golf course and country club, the very club that would one day be discussed as a possible trade for Stan Hywet.

Manning's firm also produced a report, in 1925, for the newly created Metropolitan Park District. Manning had been hired after F. A. was named to the park district's governing board. The board wanted a framework for a rural park system, the first piece of which would become Sand Run Reservation, a direct gift from F. A. and Gertrude. It wasn't the last contribution a Seiberling would make to preservation of the Cuyahoga Valley's natural beauty, but there was nothing from which F. A. took more satisfaction.

During the 1950s, when he was in his nineties and a semi-invalid, F. A. still enjoyed being taken on drives through Sand Run Reservation by his nurse. One day the nurse said to F. A.: "Mr. Seiberling, I understand that you gave a lot of your land to create this park. It must be very valuable today. Don't you miss the divi-

dends you might receive if you had sold the land and invested the money?"

F. A. pointed to a family in the park.

"You see that family over there having a picnic? You see those children playing?" he asked. "Those are my dividends."

Nature influenced the house and paid dividends there as well. If Schneider translated his notes from the Seiberling's tour of England and its Tudor mansions into a less formal, more irregular, pleasant American Country House estate, his ability to cooperate with Manning enabled him to bring the outside into the house and extend the line of the house deeper into its external environment. Schneider used his head and did it with arms, of a sort.

Instead of creating one long axis that dead-ends in the Music Room, Schneider turned the house to the southeast at the Music Room and to the northeast for the Billiard Room and F. A.'s Office. With this architectural sleight of hand, Schneider formed what always looked to Irene like outstretched arms of welcome.

From the Music Room, the London Plane Tree Allee extends the axis of the house 650 feet to the south, and from the North Porch, the Birch Allee reaches out for 550 feet, linking the Manor House to the teahouses. At the terminus of the allee, the vistas extend this natural vision for miles.

Throughout the house, the natural allure of the outdoors blends with the old English and American atmosphere the Seiberlings sought to create. In the Solarium, for instance, an expanse of windows welcomes in sunlight for the plants that, even in winter, could be brought up from the greenhouse. A fountain adds to the natural feel. But, as throughout the house, this bright, natural interior hides a strong, practical skeleton.

In the Solarium, decorative grilles hide steam radiators powered by two massive boilers in the basement. Stan Hywet's artistically carved woodwork and molded plaster ceilings cover a core of steel. Schneider used the strongest materials—and they've lasted. The Solarium wasn't just all bright light and green things, either. It also served as a gaming room. F. A., an inventor like his father, enjoyed and put into this room such machines as one that

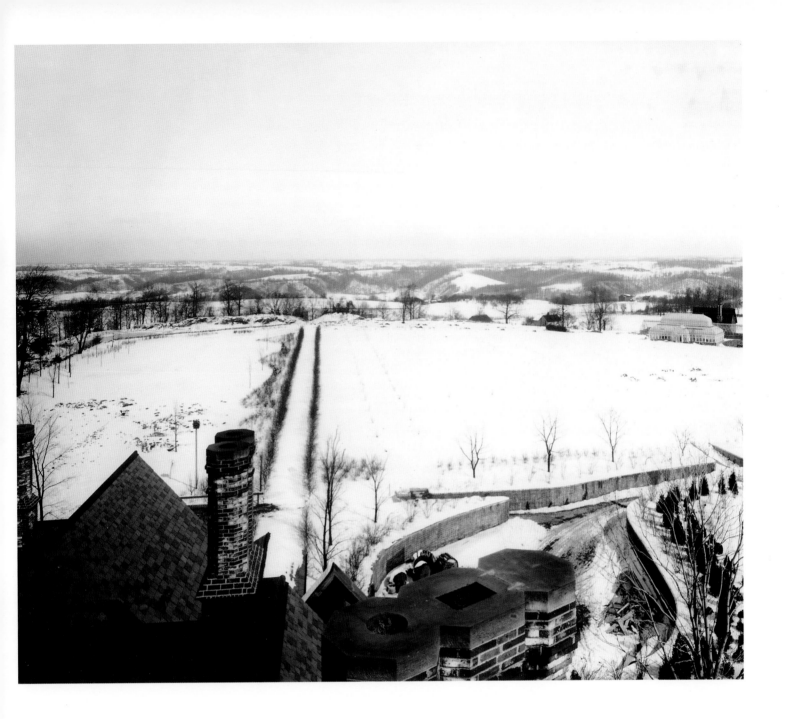

electrically shuffles cards. It may not have been quite as practical as the early tire-building machine F. A. helped to invent, but the shuffling machine served him well for the games of solitaire he liked to play before going to bed.

 With exposed timbers, Schneider contributed a feel of nature not normally present in period Tudor homes. Art historian Franklin once described it as more of a "cloister" look. That feel also is present on the long North Porch. When Irene walked the porch during inclement weather, she would be reminded of cloisters with similar porches where she had seen monks walking.

 If Stan Hywet evokes many such diverse images, two that

View from Manor House, Looking North down Birch Allee, ca. 1914

F. A. Seiberling scrupulously avoided were anything that smacked of royalty or carried over from Goodyear. He made this clear to Schneider on more than one occasion.

Throughout the four years required to build the house, F. A. would periodically challenge Schneider's ideas. Sometimes, for example, the cost of something seemed excessive. As Stan Hywet continued to grow, with another seat on the West Terrace here and an urn there, F. A. began to object. He could be won over, however, if the difference was only money. The philosophical clashes were different.

Schneider had thought that the stone pillars at the entrance to Stan Hywet might be the ideal location for replicas of the famed winged-foot symbol of Goodyear. F. A. resisted the idea. He was willing to place near the stairs in the Tower a statue of Mercury, whence the winged foot was drawn. He did not, however, want it at the estate entrance. When F. A. drove down Portage Path each evening, he wanted his thoughts to turn to the country and his family and to leave Goodyear behind.

F. A. was even more adamant about such things as shields and slogans. It had been useful for Schneider to borrow ideas from and apply his own twists to England's Tudor architecture, but F. A. wanted no part of borrowing anything from royalty for ornamenting the shields. "On the contrary," F. A. told Schneider, "I think it is an affectation, counter to the spirit of true Americanism."

So F. A. and Gertrude, at times, toned down the inclinations of their builders and decorators. With Hugo F. Huber, the interior decorator from New York City, it became a matter of mutual education. The Seiberlings would explain their feelings for family and nature and the concept of home, and Huber, in turn, made it his business to further their education concerning interior decorating. He would spend unlimited time with Gertrude, teaching her the finer points of the decorator's art. A refined man, Huber always seemed to be there, lending a hand or idea. "From the very beginning," Irene has said, "he not only helped to create the interior of Stan Hywet from a furnishing and drapery and rug point of view but also in creating the spirit. He was part of the spirit."

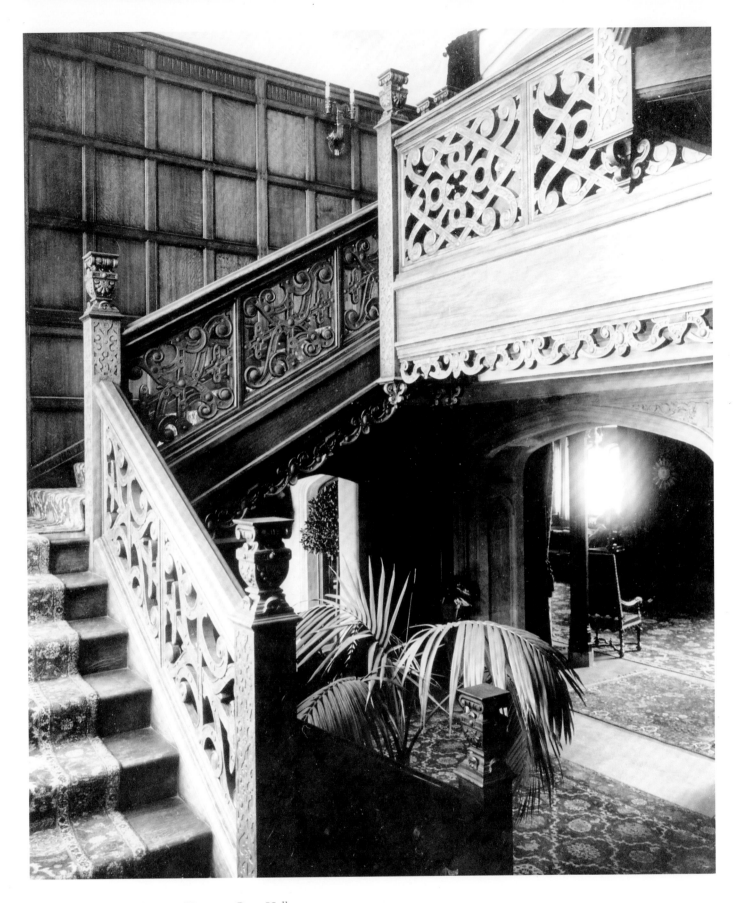

Tower Staircase, View into Great Hall, ca. 1917

Irene recalled that even after the family had moved into the house, Huber remained, not so much the decorator who refused to leave, but as a man who became a part of the family. One night, Irene saw from her second-floor bedroom a light in the Great Hall. When she got up to investigate, she discovered Huber. He would sit for awhile in one place in the room, then move to another. As he did this, he also moved the source of the light. He'd study its effect and then move it again.

"This is the way he worked," Irene said, "until he got perfection."

This was no academic exercise. Stan Hywet was as large as a small hotel. There were as many as two dozen staff members, as well as the family. This was a place filled with life, and Huber was determined to catch the nuances of it, its lights and darks. Before those days in the late summer of 1955 when the Seiberlings decided Stan Hywet would go on as an extension of the home the family had made it, much living, loving, merry-making, marrying, birthing, and dying had gone on in this place. Stan Hywet became, at times, chapel, birthing and maternity ward, and nursery. It was a grand house that became a home.

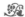

Stan Hywet Hall was opened officially on June 16, 1916, when the Seiberlings played host to a party that was then and continues to be regarded as Akron's party of parties. More than two hundred persons attended, and no one was admitted unless attired as one of the characters from a Shakespeare play.

Guests were greeted at the Stan Hywet entrance by staff wearing soldiers' uniforms. They demanded the identity of each character who arrived. Outside, electric lights gleamed in the gardens and from the trees. In the Music Room, Gertrude Seiberling held forth as Queen Elizabeth, seated on her throne.

F. A. must have been quietly appalled.

He had written to his daughter Ginny, whom he called Jink, at Westover School in Connecticut, dismayed over this very prospect. "Now this Shakespearean business that your mother has gotten us into is bothering me a good deal," F. A. told Jink. "I want to get a costume like Falstaff or the two Romeos (his brother-in-law Irv Manton to be the other) and your mother says that

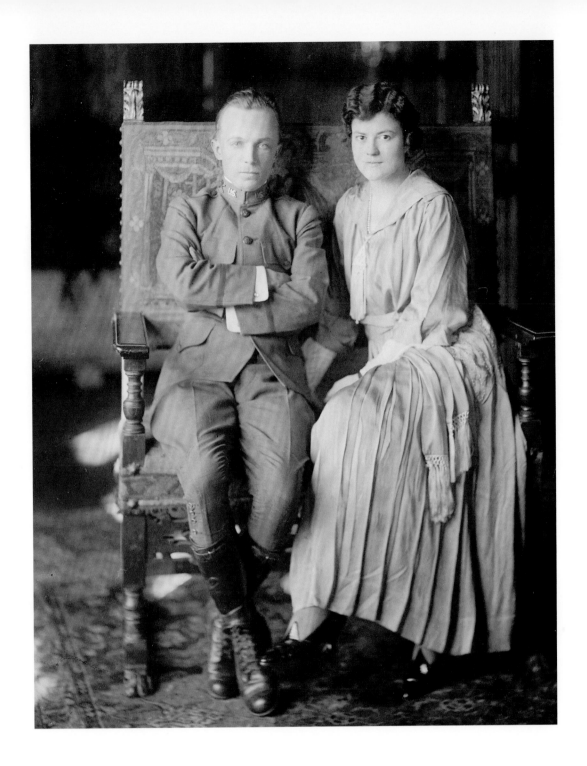

Fred and Henrietta Seiberling, 1917

isn't dignified; that I must dress like a king or a prince, or some other know-nothing."

This possibility raised the not-so-royal hairs on the back of F. A.'s neck. "I can't stand for the king business," he told Jink. "As you are well read in Shakespeare, perhaps you can suggest a compromise that will be fitting. . . ."

Jink came through. F. A. dressed as Mark Anthony and left the king business to people such as O. C. Barber, the Match King, who came as King Claudius.

There may have been no grander party at Stan Hywet, but there were more serious ones. On October 11, 1917, Lt. John Frederick Seiberling wed Henrietta Buckler in the Music Room. Fred had met Henrietta while serving with the Ohio National Guard at Fort Bliss in El Paso, Texas, during the Mexican border crisis. By the fall of 1918, Fred had been sent to a Europe locked in World War I. Fred missed the birth of his son, John Frederick Seiberling III, on September 8, 1918. It was the first of a number of births in the Tower room that was turned into a delivery room.

A month after his son's birth, Fred found himself in Paris, a city he had shared in happier, more peaceful times with his brother, Willard. He wrote to remind Willard of the days they had spent in the City of Lights in 1912 and to tell him of leaving Ligny, France, the day the Germans had rained bombs on the village. As he hopscotched his way around France, Fred seemed to be no more than one step ahead of the Germans.

"To hear the confound motors [of the planes] hum and the bombs swishing through the air," Fred wrote, "takes all the joy out of life." Then he added: "At least I am frank to admit it is the most uncanny and disagreeable feeling of an[y] experiences I have ever had in life."

His mind was on Stan Hywet, his wife and new son. He was thinking of having to spend another Christmas away and wondering if his luck would hold and he would one day see little John.

"The only thing I want real badly I can't have," Fred told Willard, "and that is my wife and little baby. My God I am anxious to hear from someone about them both and especially from Henrietta about my little boy."

Irene obliged. In ordinary circumstances, her letters were incandescent in the detail that illuminates daily life. In this instance, she made herself the eyes and ears of her brother, recording for him the events surrounding his son's birth. It "reminded me," she said, "of 'The Night Before Christmas,' when all through the house, not a creature was stirring, not even a mouse."

Since the morning of September 7, the family had been scurrying about, moving furniture out of the Tower, replacing it with clean, white enamel tables and piling them with cotton and flan-

nel garments. The bed in which Henrietta would give birth to John had been raised on wooden blocks, and with its two fluffy, soft mattresses, spotless white linen, and a white coverlet, it looked to Irene like "drifted snow." On dresser lamps, Irene had placed shades to soften to a glow the "quaint electric candle-lights."

No one suspected until breakfast that morning that Henrietta was ready to give birth. Irene had to "fly" downtown to buy white porcelain pitchers, bowls, and gauze. "It was just like the happenings the day before Christmas."

By 6:00 p.m., Irene tumbled into bed, exhausted. When she woke at 11:00 p.m. and tiptoed along the balcony above the Great Hall on her way to the Tower, she saw her father on one of the red couches below, asleep. Irene inspected one last time the room that would serve as a hospital. As she crept back downstairs, the only light came from a flickering fire. She could see Gertrude on the other red couch, hat and clothes still on.

Dr. William Chase, F. A.'s brother-in-law, arrived at midnight, and Henrietta was moved into the hospital room. F. A. had gone to fetch Dr. Chase from his home. John Frederick Seiberling was born at 4:10 a.m., and by 4:30 Dr. Chase had joined F. A., Irene, and Ginny on F. A.'s sleeping porch at the rear of Stan Hywet. From there, they announced with shouts to all the world that a grandson had been born.

The house awoke, and from bedroom after bedroom came cheering. It was, as Irene said, like Christmas, and F. A. began to sing the hymn that Gertrude performed each Christmas morning at church—"Unto Us a Son Is Born."

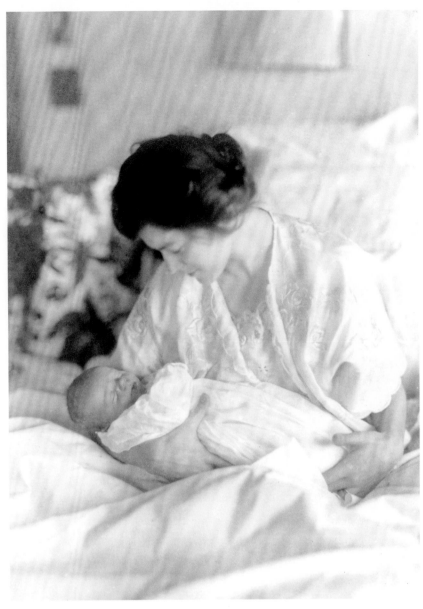

Henrietta with son John, September 1918

And the son, Irene told her brother Fred, "looks quite a lot like your baby pictures."

A home so filled with life—its glorious beginnings, the long middle period that is living, the finality of its end—could never be just a museum. Too much has happened at Stan Hywet.

🙙

While Fred and Henrietta's wedding was the first at Stan Hywet, it was Irene's wedding that became the most celebrated, in part by circumstance. Times were hard in 1923 when Irene Seiberling and Milton Harrison, a New York banker, decided to wed. F. A. was back on his feet after losing Goodyear in a financial downturn after World War I. He might have saved the company he called "my baby" from other New York bankers by going before a friendly Summit County judge and seeking to have Goodyear placed in receivership with himself named as the receiver.

"Any judge would have done it," said John Seiberling years later, Stan Hywet's first-born all grown up.

F. A. Seiberling refused to make that request. He said it would have meant restructuring the company and putting others out of work. He could not do that. So he absorbed the consequences of the collapse in 1921 when he was sixty-one, and at sixty-two started over by forming Seiberling Rubber Company. He sat in his Office, answering call after supportive call and responding to friends who had written him to express their love and concern.

F. A. Seiberling had owned thousands and thousands of shares of Goodyear stock. As the price plummeted from $100 a share to $5.25, F. A.'s worth had tumbled with it, from more than $15 million to next to nothing. Down but undaunted, the Seiberlings—F. A. with his brother, Charlie, at his side, as always—began the climb back, but this time with the help of a next generation of Seiberlings as well, especially Penny, who was graduated in June 1921 from Princeton University.

"I'd like to have you with me," F. A. told his son.

Family. It was always about family. Again and again, the important decisions in F. A. Seiberling's life were driven by family—the decision to build a home as grand as Stan Hywet Hall, to build it only after his mother's death, to include a pool and gym for the children and the Music Room for Gertrude, to find, even

in difficult financial times such as 1923, a way to make it a special place for the special people in his life.

Irene decided she and Milton should marry on Christmas Day 1923 so that the family could save money. Everyone would be at Stan Hywet anyway. She wouldn't even have to send out wedding invitations. The invitation could be incorporated with the Christmas message. People were invited to just drop by and share in the noon wedding.

"Very informal," Irene described it.

Yet very special. Gertrude, with Irene, planned every detail, from the decorations for each room to the guests who would occupy the room. Wreaths hung on the outside of the bedroom doors. Ginny and Jack Handy and their son, Jackie, occupied the Red Bedroom. Lawrence Stanley Harrison, Milton's brother and best man, and his wife were in the William and Mary Room. And Milton, tuxedo in the closet, stayed in the Colonial Room. There were so many guests that Gertrude turned the Master Bedroom over to Mr. and Mrs. Raymond C. Penfield, her brother and sister-in-law.

Regardless of the size of a gathering, Gertrude Seiberling organized events down to the smallest detail, and Irene's wedding was no exception. Gertrude was the majordomo of Stan Hywet. Irene's wedding may have been "very informal," but it had Gertrude's touch to it.

As what would turn out to be three hundred guests arrived, the sound of Christmas carols greeted them. In the Music Room, James H. Rogers, Cleveland composer and old friend of the Seiberlings, played the organ, and from the balcony, sixteen children, each holding a lighted candle, sang. They placed the candles in pots on the balcony railing, and, with only the candles and Christmas lights for illumination, the Music Room took on the feel of a cathedral.

While the traditional large Christmas tree dominated the Great Hall and could be seen by arriving guests, the Music Room's smaller trees and their lights created the feeling of a non-traditional wedding. If Christmas lighting was not ordinary wedding fare, neither were the white orchids in the room. From the Palm House in the Stan Hywet greenhouse, which was called the

Conservatory, came some of the finest orchids in the country. They matched Irene's Lanvin white satin dress with two long streamers of satin and tulle falling from her shoulders to form a train.

The dress was special. Though Irene, with her wedding's timing and its unorthodox reception, was trying to save money for her father, F. A. insisted that his oldest daughter have the loveliest dress that could be found. So Irene and Gertrude, at the suggestion of her sister-in-law, Henrietta, went to Bendel's in New York. They found her dress in the big city, but Irene knew it really came from her father's heart.

Though close to both of her parents, Irene had an unusual relationship with her father. She was almost thirty-four when she married. She had lived at Stan Hywet Hall for eight years. During those years—years she called the greatest education a· person could have had, what with her mother playing host to the musical greats and her father bringing home the high and mighty of industry and politics—Irene soaked up knowledge by association. She and F. A. would talk in the Breakfast Room in the morning about the events of the day in the newspaper. At night, they often sat down over a card game in the Solarium and talked about the day's business. F. A. always told Irene that she had a head for business. But daughters didn't follow their fathers into rubber at the beginning of the twentieth century. They married and had a family.

Irene had met Milton Harrison because of her father's interest in Lincoln Memorial University in Tennessee. Harrison was a trustee, F. A. a benefactor of the school. Harrison gained immediate acceptance from the family. Irene's aunt, Blanche Seiberling, speaking as family members gathered in the Dining Room to wish the newlywed couple well, called Harrison Irene's white knight, come on a white charger. If that sounds like a fairytale scenario, the wedding ceremony was even more so. It lived up to even Irene's expectations.

She had written to Milton as they were planning the wedding and told him: "It is going to be lovely to have our wedding on Christmas Day when [the family members] are all gathered together to witness it—and, lovely to say, they all agree that Christmas Day is a lovely time to have it."

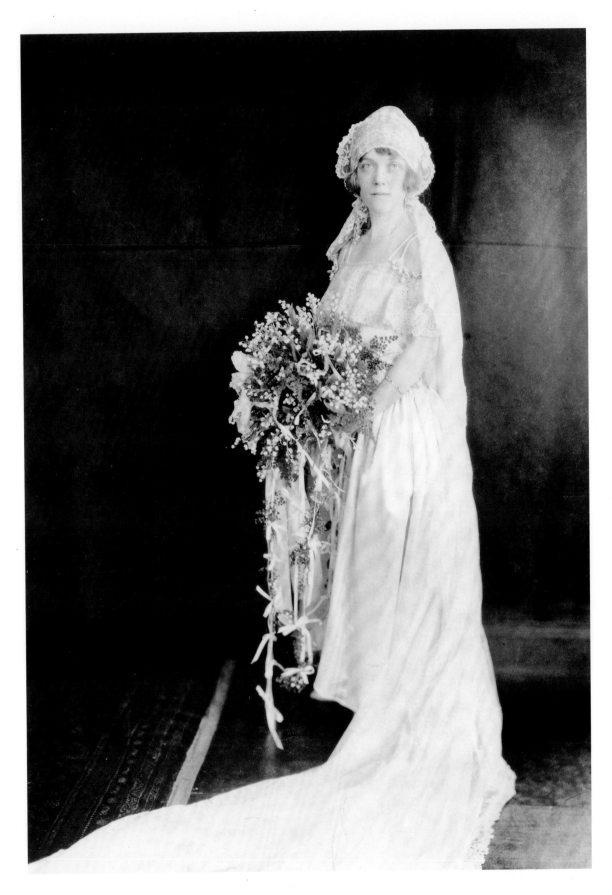

Irene Seiberling in wedding gown, 1923

Helen Wolle, Irene's cousin, was her maid of honor, and among her young attendants, all dressed in the costumes of Old England, was five-year-old John Frederick Seiberling, the nephew whose birth at Stan Hywet had so excited Irene. John was joined by Robert Saalfield Jr., Cynthia Ann Bass, Jackie Handy, Margaret Rodenbaack, and Sally Lou Handy. They carried holly and mistletoe. The boys wore green, the girls red. It was sweet and beautiful and Christmas—a combination so like Irene.

For a wedding present, she gave her husband not gifts that cost a fortune but those that meant the world to her—a set of books she owned that Milton could place in the library of the home they would make for themselves in Bronxville, New York; a tiny box, bought in Sicily, that was scented with the sweet smell of the bark from almond trees; and photographs of herself, though she told him he could discard any he didn't like.

The wedding reception was as unusual as the ceremony. There was a large bowl of punch in the Great Hall, and, instead of a wedding cake, there were little boxes with Irene and Milton's names on them, each containing a piece of cake. A family member handed a little box of cake to each person as the guests left to continue their own Christmas celebrations.

After the ceremony, family and special guests dined at a table set with the Royal Doulton English Castle and Abbey plates, sterling flatware, and crystal goblets. Garlands of Colorado spruce and white lilies adorned the table. After the dinner, Irene and Milton embarked on a six-week honeymoon to Jamaica.

Though they would live in New York after their honeymoon, Irene remained close to her family. In fact, she was at Stan Hywet, caring for her newly born second child, Gertrude, in 1928, when an even more unusual gathering than her wedding occurred.

F. A. Seiberling's family had been a part of the Akron area for a century, and Gertrude Seiberling, by 1928, had lived in Akron for more than forty years. They were a part of the fabric of the community, the community a part of them. So it was in no way odd that the Seiberlings, this old Akron family, would open Stan Hywet's grounds and play host to the biggest celebration of Akron old-timers ever—the fifty-year club.

To qualify for the club and an invitation, a person had to

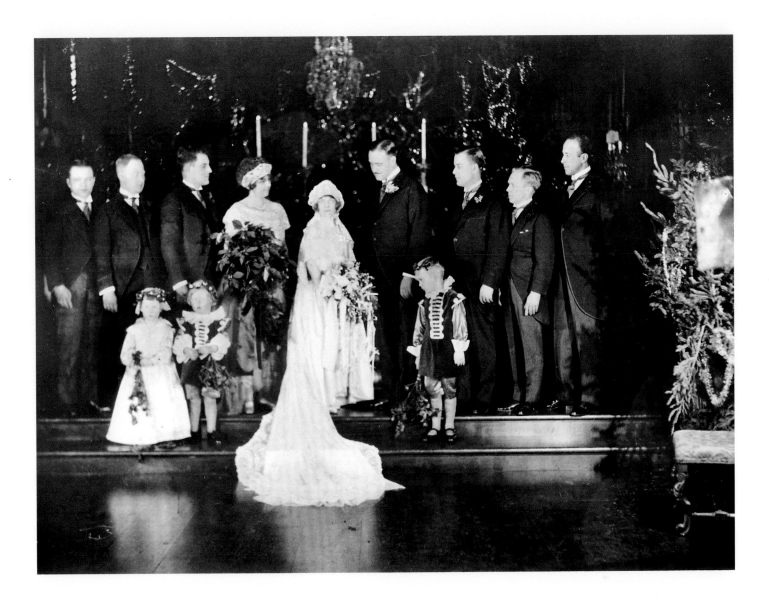

have lived in Akron for fifty years. F. A. thought that between seven hundred and eight hundred of the old-timers would show up. He underestimated. Four thousand came. There were so many people that tours of the house had to be canceled. Rows of picnic tables were set up the length of the London Plane Tree Allee. A band platform was erected on the Great Meadow, and couples do-si-doed to square-dance callers and fiddlers playing "Turkey in the Straw."

Boy Scouts and Girl Scouts took visitors to the Japanese Garden, the Lagoon, the Observation Points, and let them in on a secret of Stan Hywet's landscape, the English Garden. Sunken below the West Terrace, it could not be easily seen and was one of Gertrude's favorite places to escape to for a few minutes in the late afternoon.

Irene's Wedding Party,
Music Room, Christmas
Day, 1923; right, John
Seiberling as page

Irene was staying in the Adam Room on this hot August day. The windows were open, and as Irene cared for baby Gertrude, who had been born August 14 and named for her grandmother, she could hear the sounds of laughter and happiness wafting through the window.

"To me," she would remember of her parents, "it was one of the loveliest parties they ever had—and they had so many."

These were friends, neighbors, employees, and, yes, some people the Seiberlings didn't even know. The conversations that Irene overheard were priceless, the fabric of friendships renewed after many years, of new friendships made.

"The conversations," Irene said, "were simply rich and rare."

Equally rich were the conversations and observations that occurred when, years earlier, F. A. had invited his Goodyear foremen to the house. These men were used to the dirt and grime of the rubber shop. They smoked and drank, and four hundred of them were coming. Gertrude was worried.

A teetotaling nonsmoker, Gertrude's concern ran both to preservation of Stan Hywet's furnishings and to the comfort, physical and emotional, of the Seiberlings' guests. Stan Hywet was a home to be used, not observed. Both grandson John Seiberling and granddaughter Mary Seiberling Chapman played on furniture of great age and value without causing their grandmother to swoon. Others also have attested to Gertrude's forbearance.

Louis Turner, a friend of Penny Seiberling, visited Stan Hywet one day to seek Gertrude's advice. Turner had been to the house before, including to a dance on the first Fourth of July after the Seiberlings moved in. It had been an explosive occasion. A group that included Harvey Firestone got "a little gay" and with Roman candles had accidentally set off a large box filled with fireworks. That incident, however, was not as singularly embarrassing for Turner as when he sought Gertrude's advice concerning singing lessons that might open the door for him to join the Cornell University glee club during his days as an undergraduate.

"I remember that she expressed regret at being so busy, because she would enjoy giving me the lessons herself," Turner told Penny in a letter years later. "I took a step backward and walked into a bear or tiger rug and broke a tooth out of its head."

Mortified, Turner apologized and apologized.

"Your mother," Turner told Penny, "was most gracious and unconcerned—passed it off as [if] it was quite usual for the poor beasty to have a tooth knocked out every now and then."

As understanding and nonjudgmental as Gertrude could be, the Goodyear foremen's bash required special preparation. These men weren't Penny's school chums.

"Now, Frank," Irene remembered her mother saying to her father, "these men are smokers. We've got to have little trays for them to put their ashes on and to put out their cigarettes."

F. A. knew just the ticket. "Don't worry," he told Gertrude, "I'll get little souvenir tires with glass centers. The factory gives them out. I'll have a couple hundred sent over." The tire ashtrays, which at the beginning of a new millennium remain favored collectors items from Akron's rubber heyday, served their purpose as

Fifty-Year Club Picnic and Gathering, Great Meadow, Summer 1928

F. A. roamed the house, showing his men around the Billiard Room, his Office, the Breakfast Room, and, of course, his wife's treasure, the Music Room.

It was to that room the family retired when they thought all of the Goodyear foremen had departed. One foreman remained, unable to break the spell the Music Room had cast upon him. He stared at the pipe organ and the English portraits on the walls. He looked up into the balcony from which musicians play. After a long while, he spoke.

"This is the grandest, most beautiful room I've ever looked at," Irene recalled the foreman saying. "I'll never see a room as beautiful as this."

The foreman lapsed into a wistful, troubled silence. When he broke it, he pointed to the tire ashtrays. "But what," he demanded, "are those things doing in this room? They don't belong in a beautiful place like this. They should be thrown out."

"They're just for today," Gertrude Seiberling reassured him.

While many persons made use of Stan Hywet during the forty years the Seiberlings lived in the home, and no group was turned away, it was more common for Tuesday Musical Club members to find themselves in the Music Room than it was for Goodyear foremen. The famous and powerful—from Helen Keller and Will Rogers to musical giants Sir Johnston Forbes-Robertson, Percy Grainger, and Ignace Jan Paderewski, from Thomas A. Edison to presidents William Howard Taft, Warren G. Harding, and Calvin Coolidge—were among dozens of guests who accepted the Seiberlings' hospitality.

Stan Hywet moved the rich and famous as surely as it did the Goodyear foreman who found the Music Room so compelling. Popular tenor James Melton, who sang over the radio, in motion pictures, and on the stage of New York's Metropolitan Opera, chose the Music Room to announce his engagement, in 1929, to Marjorie McClure of Akron. Stan Hywet prompted many such professions of love, most often for the home itself.

When English dramatist Sir Johnston Forbes-Robertson visited Stan Hywet to address a meeting of the Akron College Club, he found himself so overwhelmed by the Music Room's ambiance

Percy Grainger

that he altered his routine. He had asked to speak while seated. Instead, he stood.

"I cannot possibly speak on the subject I had designated nor can I remain seated," he told the gathering. "I can only speak of the aesthetic and spiritual value a structure such as this will have on the community in which it exists."

In his career, Forbes-Robertson had seen a number of Americans attempt to buy character for their homes by importing valuable English antiques. He had always before "shuddered and trembled"—and not with delight—at the result.

"We English think that it is a great pity that many of the finest, most notable examples of art in the world are gradually being acquired by Americans," he said. "But when I see that they are being enjoyed in such homes as this, I don't know that I am sorry. I have come to a place where English antiques *do* belong.'"

Percy Grainger was equally moved and spontaneous. He had been invited to stay at Stan Hywet following a concert in Akron. The next morning, he encountered Gertrude in the Breakfast Room and proposed to her that he should run from the room, through the North Corridor, past the Great Hall, down the Linen-fold Hallway, through the Round Room and to the far end of the Music Room, a distance of about fifty yards or half a football field.

"This home gives me such a sense of joy," Grainger told Gertrude, "that I cannot walk in it. I want to run. Do you mind?"

Mind? Gertrude? How could she? Grainger's odd request was nothing if not an affirmation of her success in creating a home with a heartbeat others could feel.

"No," she told Grainger, "go ahead and run."

Those were special days. The ordinary days, family days, seemed no less special to the Seiberlings.

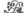

The morning light so carefully calculated to fill the Breakfast Room filled the Seiberlings' days. This was a happy, optimistic, bustling family, and its days began in the Breakfast Room, F. A.'s favorite room in the house. Invariably, he would arrive first, ready to launch into the day, mixing a huge breakfast with big ideas. His intentionally controversial breakfast topics would ignite family debate. As one of the maids saw to it that F. A. had a breakfast of two soft-boiled eggs, bacon, orange juice, coffee, and toast buttered, torn apart, and dipped into the eggs, he would read the *Cleveland Plain Dealer*, the only morning paper in those days, for ideas with which to set off conversations.

Family members would drift in, as breakfast was served until up to 9:30 or 10:00 a.m. Though the Seiberlings gave Stan Hywet a homey feel, it operated much like a small hotel with a staff catering to the needs of family and guests. Willard never forgot those morning debates.

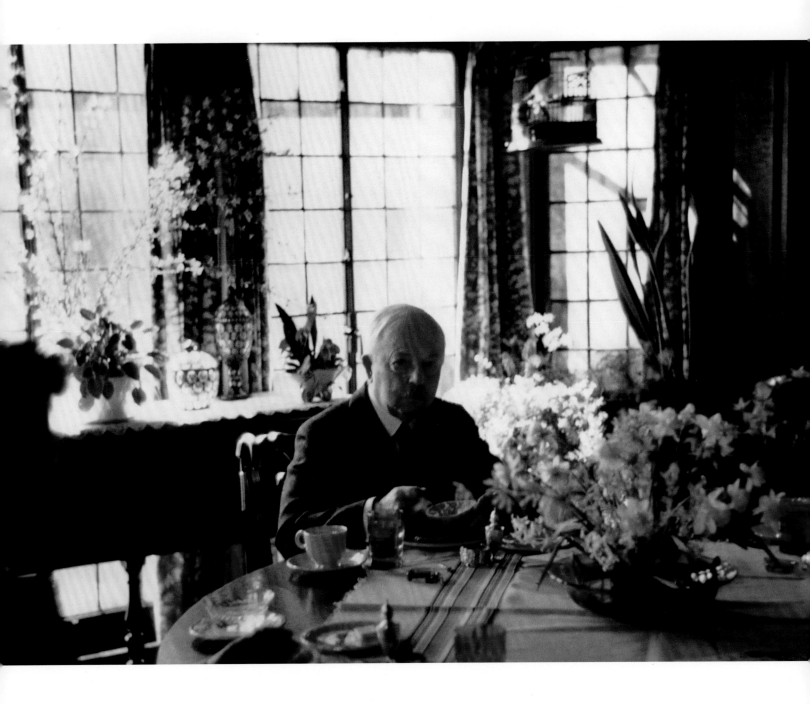

"The argument would start, and back and forth it would go," Willard remembered. "That Breakfast Room was so intimate and generally under such happy auspices that it has for me the fondest of memories."

F. A. Seiberling in Breakfast Room, 1942

Gertrude's entrance always came late and often dramatically. Anyone still in the Breakfast Room could hear her singing as she descended the stairs. "Mother," Irene said, "had such a gay spirit, such a joyous spirit." So Stan Hywet is not haunted by spirits. It is blessed by them.

Some of the sweet spirits belonged to Stan Hywet staff mem-

bers such as Mary (Alice) Kiehnlein, a laundress during the 1920s, who also cooked. She came from Germany to marry her German sweetheart, August, a machinist at B. F. Goodrich. Though the Kiehnleins lived first in Akron's German section near The University of Akron, a place called Goosetown, and then moved to Kenmore, Mrs. Kiehnlein was at Stan Hywet the day young John Seiberling needed her most.

John was three years old when he decided to emulate his Uncle Franklin and other older boys he saw swimming in the Lagoon. Since he knew the Lagoon was too deep for him, young John decided to try the goldfish pond on the West Terrace. His nurse, Miss Kniffen, thought she knew where John was.

"When I was supposed to be taking a nap," John said, "I went out and lowered myself into the water, which I found out was deeper than I expected. It came almost to my nose, and once I was in the pool, I couldn't get out because it was steep."

What to do? John decided the only way out was to wail for help. So he did. Working in the basement laundry room, Mrs. Kiehnlein heard John and came to his rescue.

John Seiberling wasn't the only daring swimmer in the family. His sister Dorothy and a neighbor girl once went skinny-dipping in the Lagoon, only to have a group of garden club ladies stroll by on a walking tour. Dorothy and her friend stayed in the deep center of the Lagoon until the ladies, none the wiser, moved on.

The games were bountiful and boundlessly pursued, and all sport at Stan Hywet tended to be "impromptu and enthusiastic," Franklin Seiberling said. "It was not approached as something dutiful or demanding." As the youngest Seiberling child and the one who grew up on the estate, he knew this better than anyone. That is not to say there was no organization.

Franklin and nephew John formed a neighborhood basketball team. The boys around Portage Path and Garman Road and beyond tended to be receptive teammates and opponents since Franklin was the only boy with a gym in his basement. Raymond Firestone, son of Harvey Firestone, founder of a rival rubber company bearing his name, played on the Stan Hywet team. Though they played other local teams, and parents and friends could come and watch, the informality of the games was what

one might find on the urban playgrounds today. "In those days," Franklin said, "no one even thought of getting team uniforms."

Informality prevailed with the adults, too. F. A. held a membership in Akron's most prestigious country club, Portage, as well as being the founder of Fairlawn Country Club, the club that showed an interest in trading its land and relocating at Stan Hywet. That did not stop him from loving to putter around the four-hole course on the Stan Hywet grounds. There was a par-three hole and three par-fours. The first tee wasn't far from the Breakfast Room, and its green was near the Gate Lodge. F. A. often would play a round not only with his sons and male visitors but also with Irene.

Everyone played tennis, and besides the family's clay court, located near the west side of the Lagoon and not far from the Japanese Garden, there was a court for the staff near the Carriage House. Equally important was croquet and its cousin, roque, a game played competitively on a formal, carefully graded, slightly sunken, flat area north of the west terrace. If there were any doubts about the permanence of sports at Stan Hywet, one need only examine the roque wickets. They were embedded in concrete.

Inside, Willard may have been using the gymnastics equipment that helped him to make the Princeton team, but most of the Seiberlings relished the more sedentary games of chess and cards or reading in the library.

Before John Seiberling was in his teens, he began to understand the treasure that could be found in the black walnut-paneled library. His father's portrait still hangs in the room where John spent so many hours, culling an encyclopedia or curled up with an adventure story. He often chose this reading to that of assigned homework.

On one wall of the library, a hinged section of the bookcases hides a passageway that leads to the Great Hall. This is the sort of secret passage that the Seiberlings saw in the English manor houses they visited. The true secret in the room, John Seiberling came to appreciate, was not hidden in the walls but between book covers and within the many magazines to which his grandparents subscribed, including *National Geographic, Popular Mechanics,* and *Scientific American.*

Though Gertrude Seiberling's touch and influence radiated from every nook and cranny, Stan Hywet Hall also was a place for boys. In the Blue Room, the connecting suite of bedrooms for the Seiberling sons and grandsons, Fred drew a version of his enemy from World War I, Kaiser Wilhelm of Germany. A generation and world war later, his son, John, returned from service to add his own caricature of Adolf Hitler.

As in other large families with close multigenerational ties, a man such as F. A. Seiberling had the opportunity to influence his grandchildren as well as his children. In his office, F. A. taught some of life's lessons not only to Penny and Franklin but also to Bob Harrison, Irene and Milton's son.

In the late 1940s, Bob Harrison had just been graduated from Western Reserve Academy, a respected private school in Hudson. Bob had borrowed his grandfather's car to pick up his things from school. During the return to Stan Hywet, he became involved in a minor accident, damaging the front fender of the car.

"When he got back, he went into Father's office to report this accident," Irene said. "I figured father would say: 'That was an unfortunate accident, but it isn't too serious. I'll handle it.'"

F. A., who was in his eighties, had another agenda.

"Have you investigated what it will cost to fix?" he asked grandson Bob.

"No, I haven't," Bob said.

"Well," F. A. said, "you find out. You get some estimates how much it is going to cost, and I'll tell you what I'll do: I'll let you stay here this summer and work on the grounds until you've earned enough money to pay for it."

"Bob was aghast," Irene said.

But he went to work. It took most of the summer to pay for the damage, and then Bob Harrison enrolled at The University of Akron.

"When he graduated from college," Irene said, "Father gave him a very beautiful letter, and in the letter was the sum he had earned that summer. It had been put in the bank and had earned interest."

F. A.'s lesson in responsibility earned him the undying respect of grandson Bob.

To the public, Gertrude Seiberling may have been the family's most obvious champion of nature. She was a founding member of the Akron Garden Club, in 1924, and became its first president, serving for five years. During that time, Gertrude helped the club not only to establish strong local roots but also saw to it that it branched into national organizations, gaining from the association.

She served as extension committee chairwoman of the Women's National Farm and Garden Association, in 1931, when Mrs. Henry Ford presided over the organization. Mrs. Ford, in fact, visited her committee chairwoman at Stan Hywet, sharing the May beauty of the estate and telling Gertrude, wistfully: "I would like to work around the flowers a little myself, but I don't have time. I do go out with the gardeners every day, though, and supervise." Gertrude played a similar role but also provided a hands-on touch, working regularly in the Cutting Room of the house. Whatever the vehicle, whether flowers or the oil paints of her later life, Gertrude Seiberling was an artist. She made her art a part of the Seiberling family life, and she made herself a part of the art.

In the late afternoons or the early evenings, just before dinner, Gertrude liked to steal away to the English Garden. Surrounded by the serenity of that garden's overpowering greenness, she would drink tea and share the silence. There were not many silent moments in a life perhaps most noted not only for her own singing but also for the drive and organization she lent to music in Akron and the nation. When she was remembered by the Tuesday Musical Club upon her death in 1946, it was this way: "She came a stranger to Akron [and] left a builder."

Gertrude Seiberling created the Tuesday Musical Club, which remains a force in the community today. It met often in the Music Room to hear its own members perform, including Gertrude, and to listen to persons of national and international prominence. She never outgrew her local interests, remaining an active member of Tuesday Musical Club for fifty-eight years, but, as she did in gardening, Gertrude expanded Akron's horizon. She helped to reorganize the National Federation of Music Clubs during a meeting of its executive board at Stan Hywet in Decem-

ber 1917. She became not only the new organization's founder but also its president, and she visited more than twenty states gathering support. The effort was such a success that Stan Hywet became a focal point not only for Tuesday Musical Club gatherings but also for national meetings of the National Federation of Music Clubs.

On the evening of Monday, January 7, 1946, Gertrude Seiberling had a taste for lobster thermidor and apple pie, foods she was supposed to avoid as she approached her eightieth birthday. The next morning, she had not come down to breakfast by 10:00 a.m. Her upstairs maid, Lorraine Mullen, a young woman from West Virginia, felt uneasy. She told her friend, Libby Ciriack, who was the cook, that she was worried about Mrs. Seiberling. Libby summoned her mother, Elizabeth, who had worked for twenty years as a laundress at Stan Hywet. They went up to Mrs. Seiberling's room.

They found Gertrude on the daybed. Her heart had failed. She had been dead for ten to twelve hours. Elizabeth and Libby sought out chauffeur Louis Patrick, who telephoned Seiberling Rubber Company to break the news to F. A.

On Thursday, January 10, the house into which she had breathed so much life, in which the lives of John Seiberling and several of her grandchildren had begun, was opened for a funeral service. Hundreds of mourners paid their last respects to Gertrude Seiberling as she lay in her coffin on the west porch. Just through the doors in her beloved Music Room, the Cleveland String Quartet played her favorite pieces. She was buried in a private ceremony at Glendale Cemetery, another famous Akron citizen at rest.

After Gertrude's death, Lorraine Mullen became afraid to sleep by herself in the housekeeper's room and would not go onto the second floor unless accompanied by Libby Ciriack. It wasn't long before the Seiberling children began to discuss what would become of Stan Hywet.

So much had happened at the estate, from the ordinary events of most days to an extraordinary moment in the summer of 1935 when Henrietta Seiberling helped to bring together at the Gate Lodge Bill Wilson of New York and Dr. Robert Smith

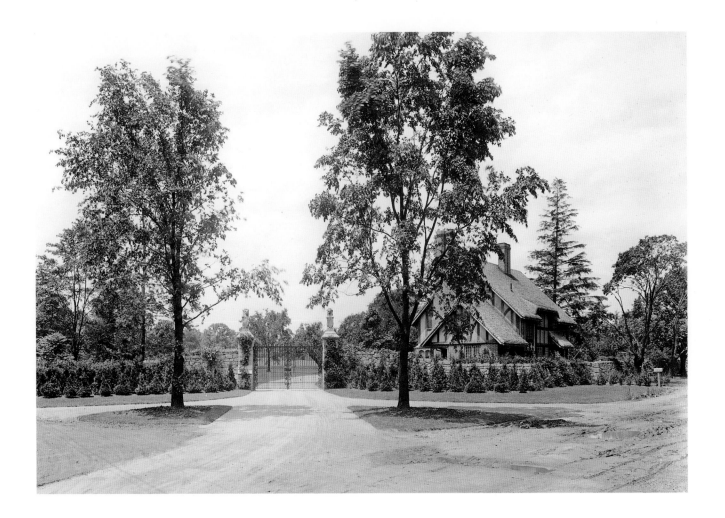

of Akron. The result was the formation of Alcoholics Anonymous.

Henrietta was not an alcoholic. But she was involved with the Oxford Movement, which sought to breathe new life into religion. It was at one of the Oxford meetings that Bob Smith announced: "I am a silent drinker, and I can't stop." A few weeks later, Bill Wilson came to Akron and through Harvey Firestone's minister was introduced to Henrietta. Wilson told her: "I'm from the Oxford group and I'm a Rum Hound."

Henrietta, influenced, she believed, by God, had shared with Bob Smith the notion that he could not "touch one drop of alcohol" if he wanted to conquer his drinking. When she put Smith and Wilson together, they began to see how they could help each other with personal support, offer the religious teachings of the Oxford group, and share their stories with others. From the Gate Lodge at Stan Hywet, Alcoholics Anonymous spread throughout the world, changing millions of lives. Henrietta Seiberling never

wanted credit. In fact, her role was not revealed until her son, John, told of it after her death in 1979. She was honored for her role, in 1998, when she was inducted into the Ohio Women's Hall of Fame, and the Gate Lodge is listed as a National Historic site in its own right.

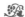

It is fitting that another group of unassuming women would save Stan Hywet. It was one thing for the Seiberling children to decide they could afford to give Stan Hywet to the community. It was quite another for the community to decide it could afford to accept this unprecedented gift. The women accepted on faith that they could do what the businessmen of Akron feared they could not. The men believed hard, cold numbers. The women believed what their hearts told them.

Charles Schneider would have told the men what they had to do: Listen to your heart. His was with Stan Hywet, first, last, and always. He and F. A. may have squabbled over costs, but both men loved this place they built together. When Schneider died in 1932, his widow, Georgia, wrote to the Seiberlings and thanked them for their concern for her loss.

"His entire association with you," she told the Seiberlings, "was such a joyous one. I believe the happiest period of his life was the four years that he spent in designing your beautiful home and seeing his dream child come to life. Charles left many beautiful monuments to the world, but the one he and I both loved best was Stan Hywet Hall."

In those important days of 1955, the Seiberling heirs decided that this place that so many had loved, most of all their parents, F. A. and Gertrude, had to be saved.

"There is a destiny that shapes our ends," Irene Seiberling said. "It was meant that this place be saved."

That did not preclude the family taking steps to assure Irene's future, and Fred's as well. Informal arrangements were made with the Stan Hywet Hall Foundation for Irene and Fred to have a home at Stan Hywet as long as they lived. Fred moved into the Cromwell Bedroom in the Tower, and Irene occupied the Adam Bedroom. No one could have known that Irene, who later would move to the Gate Lodge, would live until 1999.

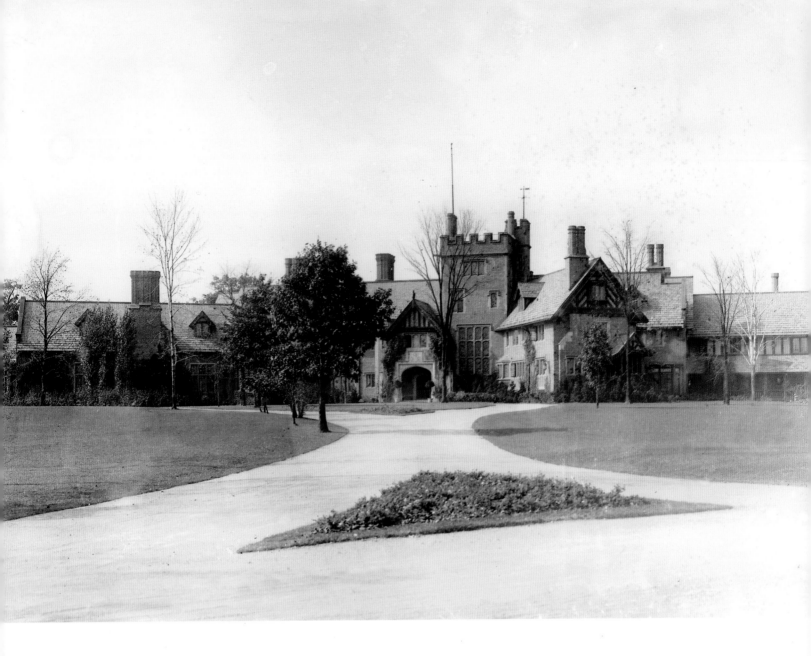

The presence of Fred and Irene, as well as the other Seiber-
lings on a less regular basis, helped to set the tone that Stan Hy-
wet retains to this day. After the family had turned Stan Hywet
over to the private foundation, Penny visited the house one day
only to discover an exhibit that did not fit in.

"This is not a museum," J. Penfield Seiberling reminded the
Foundation. "This is a home."

And a home, at heart, it remains.

Main Entrance Court,
Manor House, ca. 1916

SPRING

Dutchman's Pipe Vine, English Garden

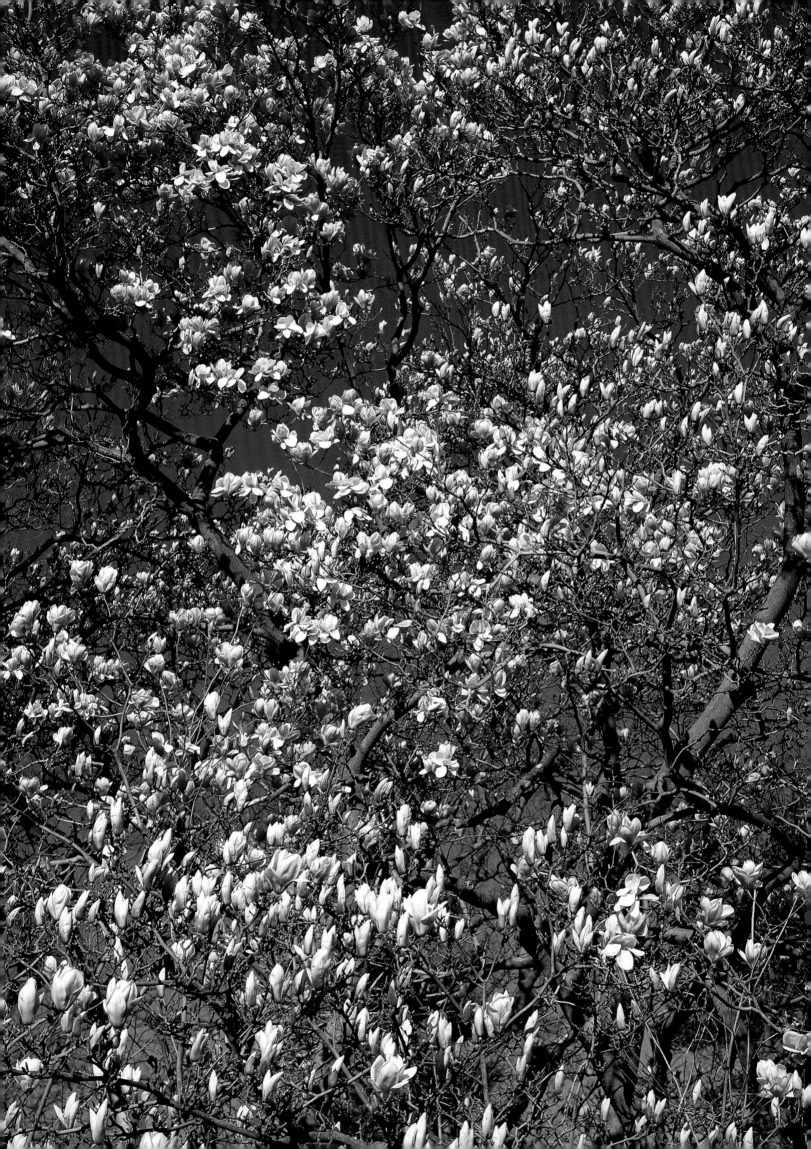

Spring offers nature and those who would fool with it—try to improve upon it, put their stamp on it—another chance. At Stan Hywet Hall and Gardens, temptation comes with the season.

And the temptation is great.

Stan Hywet Hall's grounds suggest nothing to the landscape artist if not a seventy-acre canvas. These artists come in many categories—landscape architect, horticulturalist, garden-variety gardener. They share a common ache to haul out a pallet of textures and colors and to go to work on nature. Some at Stan Hywet have given in to this ache.

In the years after the Stan Hywet Hall Foundation assumed responsibility for this American Country House estate, changes occurred—in the 1960s, '70s, even the early '80s. Everyone wanted the best for Stan Hywet Hall, to guarantee its success. The vision for what Stan Hywet should be was evolving, unfixed. So new gardens were planted, bigger display beds were dug and filled with flashier flowers of brighter colors. In trying to make Stan Hywet Hall attractive to the public that would spell its success or failure, the artists began to stray from the path laid out by the Seiberlings and landscape architect Warren H. Manning.

Manning had used natural elements. He created a footprint, a design on a piece of earth, that has withstood the test of time—the pathways and vistas, gardens and trees, roadways and waterways. The twentieth century was young when Manning first tramped the Akron countryside acres that would become the Stan Hywet estate. He found his vision of the landscape in what was present, not in what he could add to the land. On the cusp of the twenty-first century, Manning's vision was in the hands of the late Carl Ruprecht, his spiritual and artistic descendant.

Ruprecht's favorite color was green, and no season at Stan Hywet comes in as many shades of his favorite color as spring. From chartreuse to forest green, from the reds and bronzes of leaves on their way to green, the Stan Hywet canvas becomes verdant swoops and swirls.

Saucer
Magnolia
near Manor
House

51

"Because of the variety of trees," Ruprecht said, "it is a masterpiece."

This garden. That allee of trees. This vista. That lagoon. Individually, they do not make the Stan Hywet landscape what it was in its 1915–30 heyday and is once again. Rather than its parts, Stan Hywet's dominant feature is its whole, not the trees, but the forest—and the forest is easy to see.

Many American Country Houses have been torn down. They've changed hands, often more than once. Stan Hywet has had a different, better fate. It had one owner, the Seiberlings, and artistic owners, at that. And it had one landscape architect, Warren Manning of Boston. Not only did Manning design the original landscape, working with what he found rather than forcing his vision onto the land, but he also sent his young assistant, Harold Wagner, to Akron to supervise the digging and planting, the pruning and crafting.

Like nature itself, the landscaping remained a work in progress. Manning returned to Stan Hywet Hall in 1928, a dozen years after he had finished his work. He came to tramp the grounds again, to reclaim the vistas that were becoming clogged by limbs that once had been fingers but now were muscled arms, their foliage grown so thick and lush that it blocked the view of the Cuyahoga Valley beyond. Manning pointed out branches to be cut. He designated the height of the cuts. No detail was too small for his attention. He left nothing to chance.

As he worked, deciding what should stay and what should go, Manning's vision remained broad and inclusive, as it had been when his cooperation with architect Charles S. Schneider allowed them to fuse house and grounds so successfully. Manning, for instance, told the Seiberlings in his 1928 report that the sickly evergreens near the house's front entrance should be replaced by rhododendrons and the lilac and magnolias removed, the best of them to be replanted, allowing them not only more room for growth but also permitting a better view of the front exterior of the house. Manning saw the whole picture.

"The footprint has held up," Carl Ruprecht said. "In the landscape industry, a lot of people tell us we are fortunate that the footprint is still so intact."

In part that is because Manning re-
turned in 1928 to reset that footprint,
improve it, deepen it. It was in 1928 that
Manning suggested to the Seiberlings
that they invite Ellen Biddle Shipman to
repair and remake the English Garden.
"I consider her," Manning wrote, "one
of the best, if not the very best, flower
garden maker in America."

Not the least of Manning's strengths
as a landscape architect was his willing-
ness to recognize his weaknesses and the
strengths of others. It's why he involved
T. R. Otsuka in creating the Japanese
Garden and why he turned to Ellen
Shipman when he saw that the English
Garden needed something that did not
play to his naturalist bent. During her
career, Shipman designed some 650 gar-
dens, most of them private ones such as
at Stan Hywet Hall. The English Garden
is one of only two Shipman gardens that
remain and the only one that has been
painstakingly restored and is open to the
public.

*Mayapples and Periwinkle,
the Dell*

Perhaps because the Seiberlings' wealth was dissipated in the
1930s and '40s, no other landscape artist was brought in, as has
been the case at similar properties. "If the Seiberlings had still
had their wealth," Ruprecht said, "we could have lost Manning's
major footprint. Luckily, that didn't happen. Bringing back the
footprint is complicated enough."

Landscape footprints can be as distinct as that of the leg-
endary Bigfoot—and as difficult to follow. Dig through an eight-
inch layer of leaves, into the dirt beneath, and find a stone. Then
another. Dig farther. It's a stone path. Manning made such dis-
coveries. Today's landscape artists rediscover his discoveries. They
find the hint of a depression in the ground. So they look a little
longer, a little closer. They check it against old photos and corre-

spondence between Manning and the Seiberlings. A large depression turns out to be a planting bed long forgotten. A narrower, deeper depression marks where an elm tree stump once clung stubbornly to the earth. It is a green puzzle that must be solved if the grounds, like the house, are to be historically accurate and reflect the vision of the Seiberlings.

The goal is simple: Make the landscape so familiar that it looks as if F. A. Seiberling just walked into his office from the Breakfast Room Garden, as if the English Garden awaits his wife, Gertrude, for another of her quiet moments there. Achieving this goal can be complicated.

When, during the 1980s, the staff and Stan Hywet Hall Foundation directors rededicated themselves to preserving and

Azaleas outside
Breakfast Room

restoring the house and grounds to their 1915–30 glory, it became a delicate, sometimes controversial, task. Newer traditions, such as the chrysanthemum garden in front of the house, had to be abandoned. The mums were beautiful. They had been there for twenty years—all of those years after the Seiberling era.

When Ruprecht and his staff removed the mum beds and renewed the lawn of what is known as the Great Meadow, the trees and the house itself again became the focal point for people driving through the front gate and up the long roadway toward the house. F. A. Seiberling had insisted that Manning take into account this view from the perspective of a person sitting behind the wheel of an automobile. The Seiberlings, like Manning, left nothing to chance.

That is why Shipman's feel in the English Garden was restored, in 1992, and why seventy-two new apple trees now line Estate Drive. Manning, heeding what F. A. had said about the driver's perspective, had taken advantage of a natural element, an existing apple orchard, through which to wend the drive. Over the years, so many of the apple trees had died or fallen into decline that, by 1996, only six or seven remained. Ruprecht's staff began the orchard anew but with trees that conformed to the first orchard. The new versions of old-time apple varieties were grown with the help of Davey Tree Expert Company of Kent, Ohio. They include Baldwin, golden delicious, Grimes golden, Rhode Island greening, northern spy, and fameuse.

White blossoms and spreading branches alongside the green, green grass of the Great Meadow will make future springs at Stan Hywet even more like the first springs the Seiberlings experienced.

While green may be the dominant color of spring at Stan Hywet, striking accents catch the eye, and scents so lovely they seem to come in colors fill the air. From the Music Room to the south extends a finger that is variously referred to as the London Plane Tree Allee or Rhododendron Allee. For ten or eleven months a year, the plane tree, a variety of sycamore, is marked by its subtleness. The cool green of summer. The bare-limbed skeletons of winter. Then comes spring, and the rhododendrons and azaleas turn into barkers of color, luring strollers into the allee as if they were a tent on the midway at a carnival. It's irresistible.

As breathtaking as the London Plane Tree Allee can become when it is transformed into the Rhododendron Allee, it is the Breakfast Room Garden that may best convey the fresh start that is spring at Stan Hywet.

The Seiberlings loved the Breakfast Room. It was one of their more intimate gathering places, a sunny space in which to share conversations and the beginning of a new day. When, in late April and early May, the sun began to hint at not only brightness but also warmth, the Breakfast Room doors could be flung open for the inside-outside, outside-inside feel that contributes to Stan Hywet's uniqueness.

With the nearby trees not yet in full leaf, the spring Breakfast Room Garden is at its sunniest and most colorful. Azaleas, for-get-me-nots, and other pastel flowers in yellows and blues pick up the colors of the Breakfast Room and transport them outside. The person inside, eating, feels as if he or she is outside in the garden. A fountain's sweet sound creates a tranquility that settles

Allium and Viburnum
near the Greenhouse

into the soul. This intimate little garden may be as much a tribute to Warren Manning's genius as any of the larger landscaping touches he created.

"He didn't just walk us out into the great big open lawn," says an admiring Ruprecht. "He created a 'room' to make a transition."

Inviting transition is both the essence of spring and what the Stan Hywet horticultural staff is attempting to create with its examination of old photos, its scrutiny of an old plant list found on cutting garden panels, its digging into old correspondence or anything else that might lead to the discovery of heirloom plants, those in vogue between 1915 and 1930. Sometimes the old plants remain in today's cutting gardens and can be restored to their previous prominence. On other occasions, when the heirloom plant no longer can be located, the landscape artists search for the next best thing, the plant that will allow them to retain the design sensitivity established by Manning and the Seiberlings.

The footprint makers believed in taking advantage of nature. They understood that beauty did not have to be contrived. It could be cultivated.

Forsythia and Lamps near Breakfast Room

Overleaf: Rhododendrons near Main Entrance, Manor House

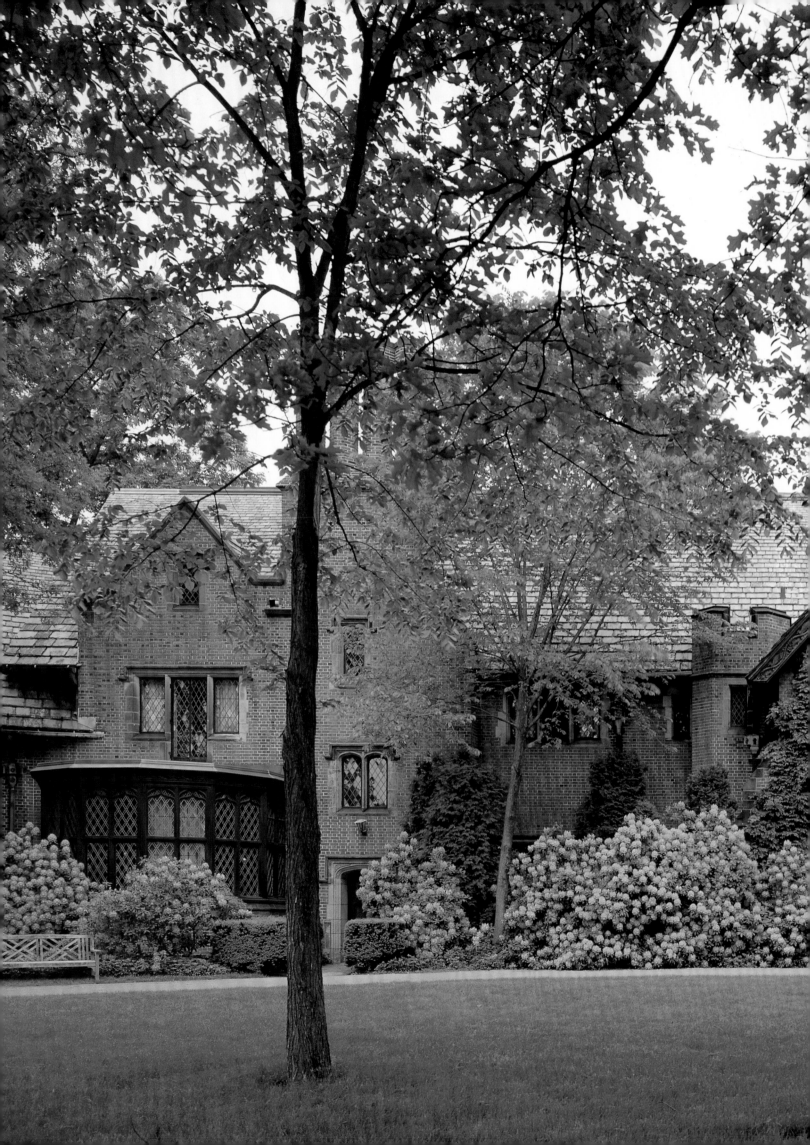

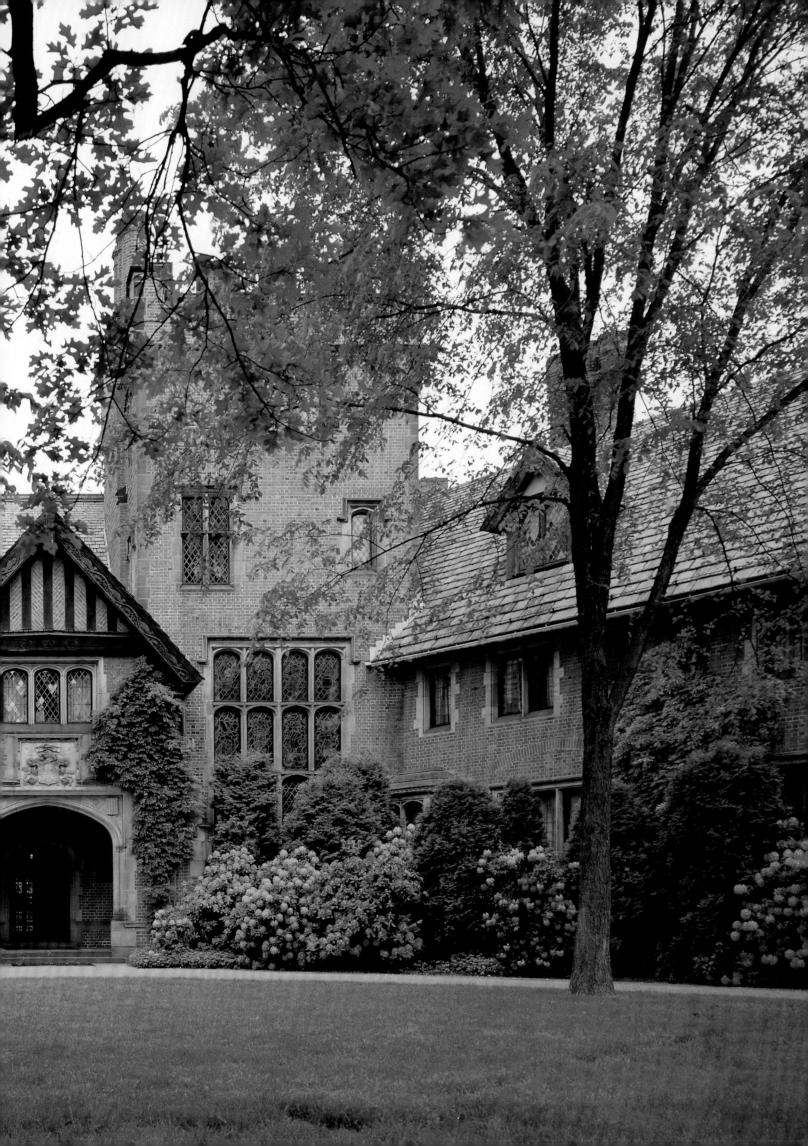

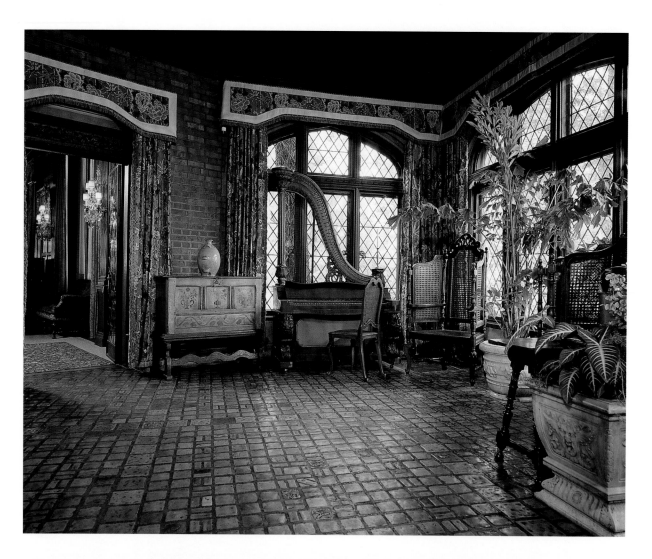

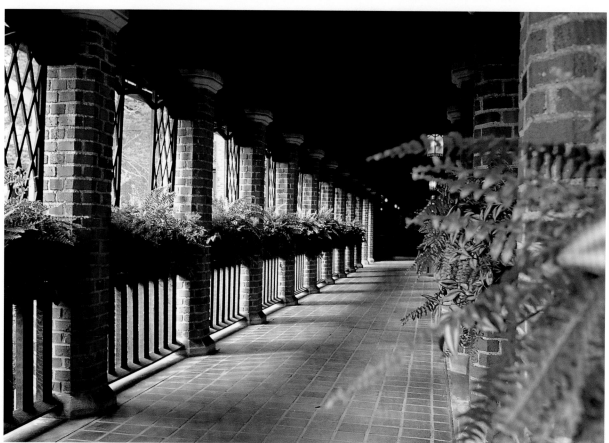

West Porch

North Porch

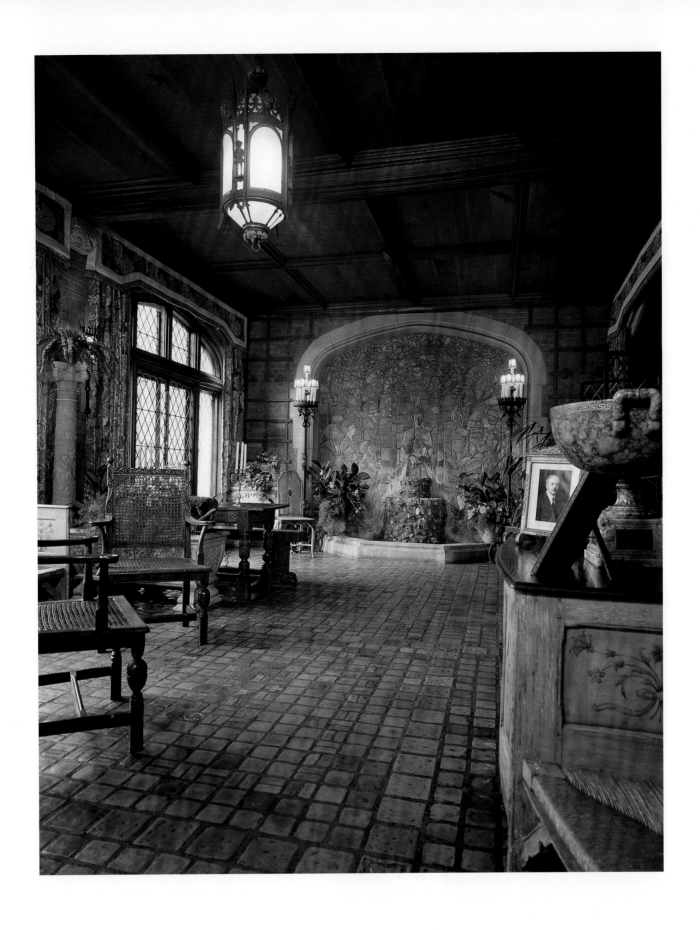

Pewabic Wall Fountain, West Porch

[61]

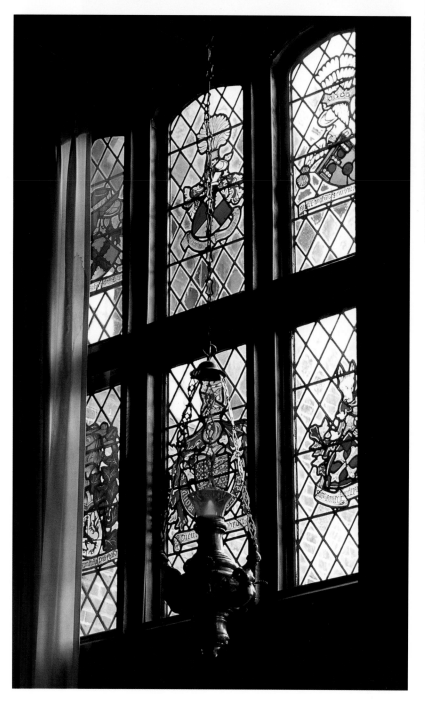

Wrought Iron Lock Set by Samuel
Yellin, Great Hall Door

Leaded Windows, Great Hall Alcove

Preserved Floral Arrangement,
Great Hall

Peonies, English Garden

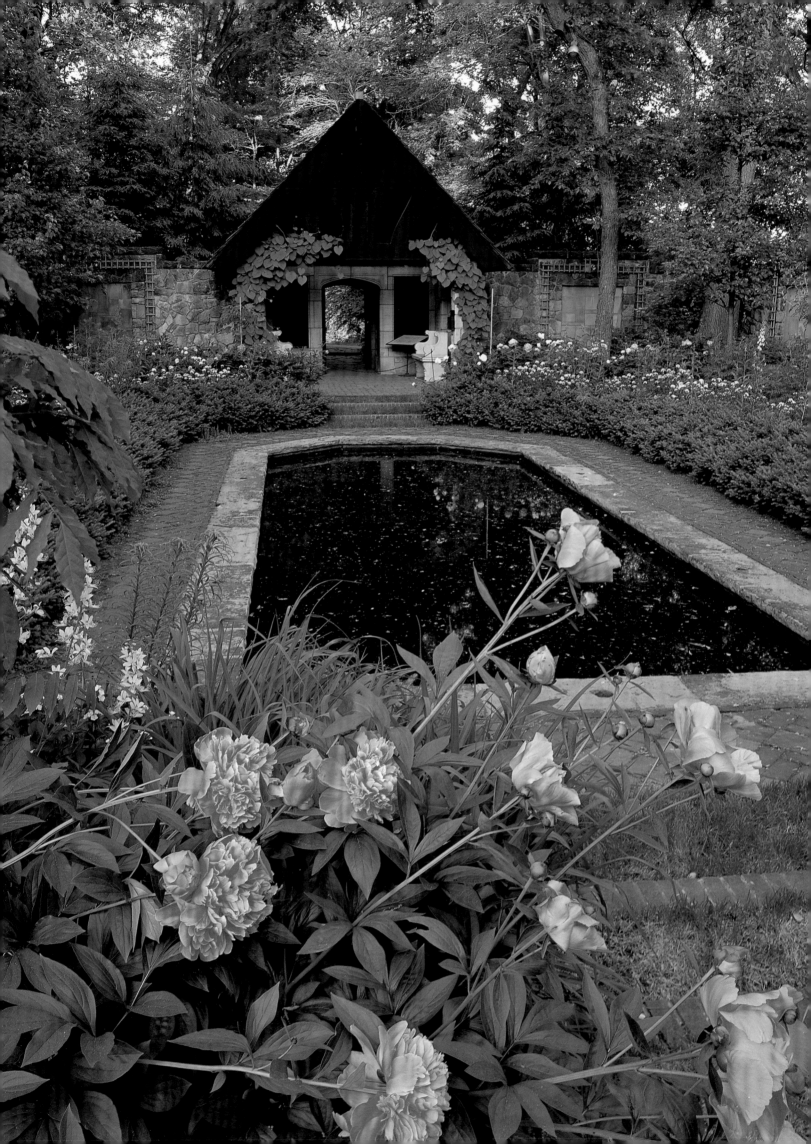

Rhododendrons, West Terrace

Tulips, West Terrace

Great Hall, View from Minstrels' Balcony

Tulips near Carriage House Entrance

Frog, Japanese Garden

Dogwood near Japanese Garden

Ferns and Azaleas, Japanese Garden

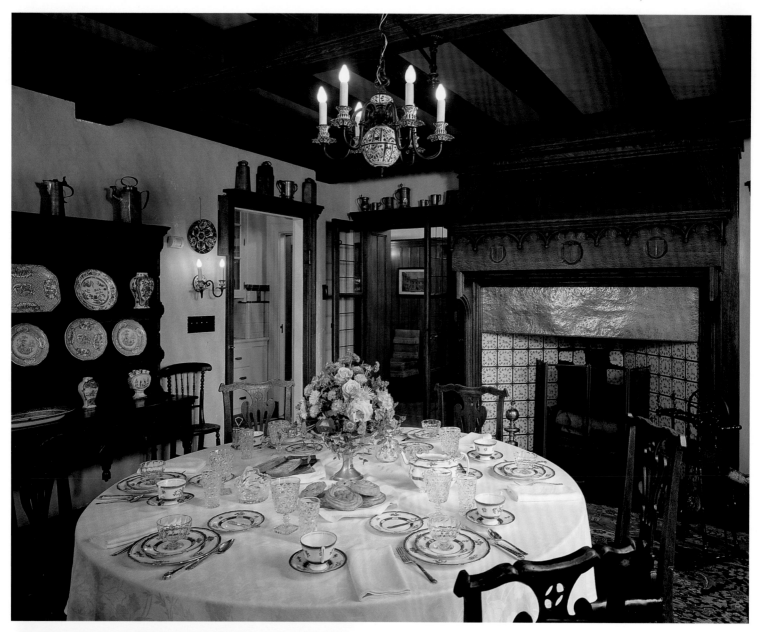

Breakfast Room, View to Pantry and North Corridor

Fresh Floral Arrangement, Breakfast Room Table

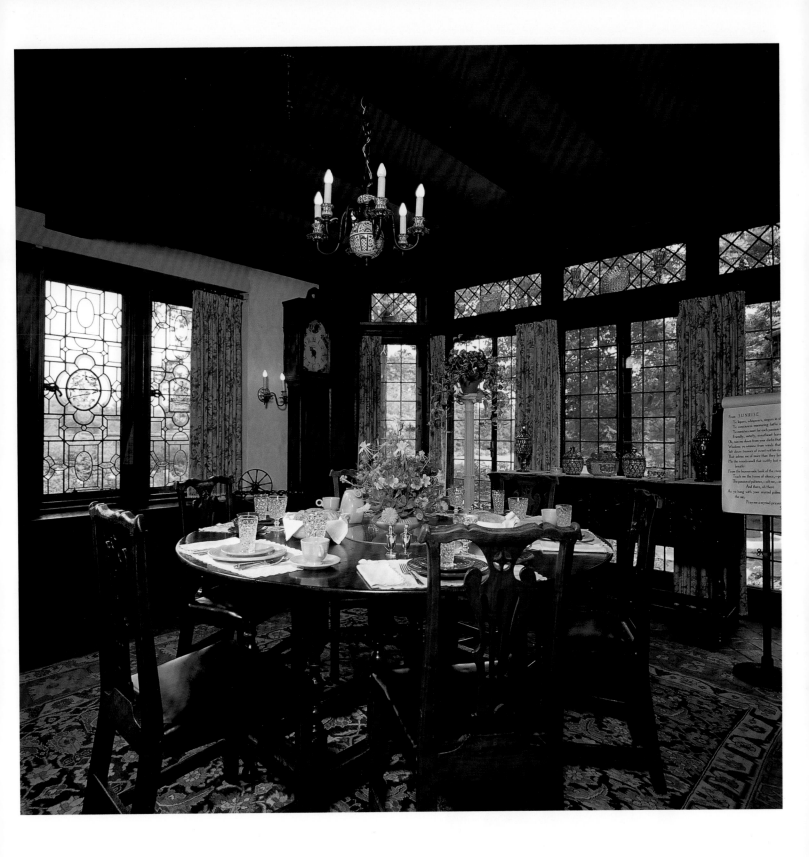

Breakfast Room

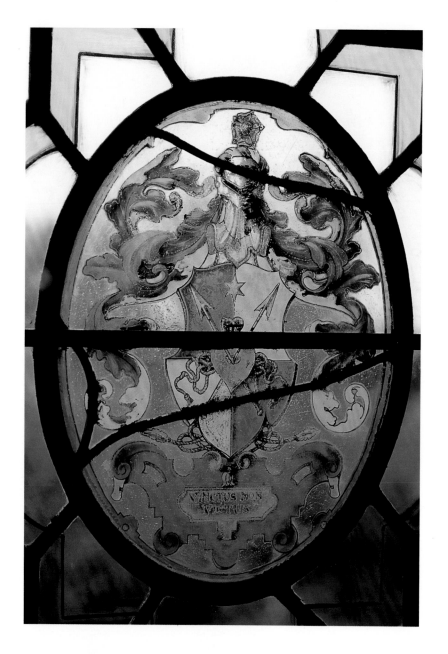

North Windows, Stained Glass Medallions, Breakfast Room

Breakfast Room Garden Fountain

Pansies near Carriage House

Azaleas and Rhododendrons near West Terrace

Forsythia along Service Drive

Yellow Iris, Lagoon

Fiddlehead Ferns, the Dell

Rhododendron and Waterfall, Lagoon

SUMMER

Water Lilies in Pool, West Terrace

The summer of 1921 loomed. Its official beginning, Memorial Day, was little more than two weeks away. Some of the evenings at Stan Hywet Hall still hinted that spring had not yet finished with the estate. But the chill that had seeped into Frank A. Seiberling's bones had nothing to do with the temperature outside his Stan Hywet office.

He was out in the cold. He had lost his "baby." In the post-World War I depression, Goodyear Tire and Rubber Company had been caught with too much inventory and too few markets. F. A. and his brother, Charlie, resigned on May 13, leaving the largest rubber company in the world in the hands of Dillon, Read, a Wall Street banking firm.

On the morning after what F. A. would always think of as "Black Friday," he went to his Stan Hywet office. For weeks, the telephone had been ringing with one bit of bad financial news after another. Now, on this Saturday, the telephone had begun ringing early and had kept ringing. Caller after caller expressed concern for F. A. and sympathy regarding the loss of Goodyear. Everyone had the same question: What would he do now?

F. A. Seiberling could not answer the question. The only thing he knew was that he was sixty-one years old—and broke.

In the Breakfast Room Garden, just outside F. A.'s Office, late spring went on as if financial disaster had not been visited upon the owner of the estate. Azaleas bloomed. So did irises, forget-me-nots, lilacs, and rhododendrons. Together, they created a floral rainbow and brightened the day after Black Friday. As more days passed and May turned into June, F. A. began to feel better. He relaxed. He let the serenity of a Stan Hywet summer wash away some of the bitterness he felt toward the bankers who had taken over his company.

Beautiful sunsets colored the evenings. F. A. could stand on the west terrace and watch the sun stream through the trees surrounding the West Overlook, bathing the terrace fountain in a

Morning
Glories
outside
Breakfast
Room

golden glow, as if someone had flipped an electrical switch and turned on a set of fountain lights. Those evenings and mornings were the nicest times, with their cool hello-and-goodbye kisses to early summer days.

When it got too hot—there was and is no air conditioning in Stan Hywet Hall—F. A. could stroll down to the Lagoon, the feature of the estate on which landscape architect Warren H. Manning heaped the most praise. There, F. A. could cool off with a dip or just watch others, family and staff alike, as they did. Manning had judiciously supplemented nature, adorning with ground cover, rambling roses, bittersweet, and tawny daylilies, the area surrounding this shelf of water that overlooked the Cuyahoga Valley. The lilies created a striking orange-hued contrast to the blue of the Lagoon.

At the end of a summer's day, F. A. enjoyed visiting the West Terrace pool and feeding the more than a dozen large goldfish. He found it relaxing, and relaxation had been a rare commodity in F. A.'s life. Even when he had been on vacation, at Stan Hywet Hall or away, business always seemed to intervene. Now, he had no business and, of course, no money.

"Yet I cannot remember," F. A. said, "having in my whole life a better vacation."

With Gertrude and their daughters, Irene and Ginny, F. A. set off during that June of 1921 for New Jersey, where son Penny was being graduated from Princeton. These summer trips and longer ones to Cedar Lodge, the Seiberlings' complex on one of the Les Cheneaux Islands near Hessel, Michigan, gave the Stan Hywet Hall staff of sixteen to twenty the opportunity to lead lives more their own. Work on the estate, particularly the gardening, didn't come to a halt, but with the family gone, the demands were fewer.

Like the family for whom they worked, the housemaids and chauffeurs, the cooks and butler, the ladies maid and gardeners had lives filled with love and marriage, births and deaths, good times and bad. The Seiberlings could not help but observe and share in the lives of their staff. As well as a home, Stan Hywet Hall was a job, not unlike those that might have been offered in a small hotel.

Early Evening, West Terrace

Staff days began at 7:00 a.m. Monday through Saturday, an hour later on Sunday. Twelve-hour days were common. When a staff member drew the late shift, responding to visitors and the house communication system, the day could last until 10:00 p.m. The workdays, however, were shorter in June 1921, with the Seiberlings away at Princeton and then at Cedar Lodge.

F. A. took pride not only in Penfield's graduation but also in the fact his son had been elected an Ivy Orator. As his family sat with those of the other members of the Class of '21 in front of Princeton's historic Nassau Hall, they had the opportunity to hear Penny speak.

"Somehow," F. A. said, "as my pride in Penfield swelled, I seemed to see my own situation a bit more clearly, and not alarmingly."

Visiting Cedar Lodge could be equally uplifting. The Seiberlings had discovered the island in 1900, when F. A.'s sister, Grace, and her husband, Dr. William Chase, had invited the Seiberlings to visit them on this raw, wild strip of land. As taken with the island as the Chases, the Seiberlings agreed they would join the Chases in trying to find enough money to buy it and make it their summer home. The Chases would take half of the island and the Seiberlings the other half.

F. A. learned that a Mr. Hill of New York owned the island. Hill had bought the island in a tax sale. Though he had never seen the island, Hill wanted $6,000 for it. That was too much. The Chases didn't have that kind of money and, of course, neither did the Seiberlings. Only two years before, in 1898, F. A. and Charlie had launched Goodyear by going door to door to family and friends for funding. So now, their money was otherwise occupied.

F. A. didn't give up on the purchase, though. But unlike his experience with building Stan Hywet Hall and its ever-escalating costs, F. A. ended up getting his island for less than he could have imagined. As it turned out, Hill died not long after F. A. first approached him about selling the island. Hill's widow and son also had never visited the island. So following Hill's death, F. A. contacted the widow during a business trip east. After going through her husband's papers, she agreed to sell the island, which she con-

Cook's Pantry

sidered useless to her. Grace Chase said the price of the island was established by the Hills writing to Joseph Fenlon, owner of the Hessel General Store and an expert on the area. The Hills wanted to know how much the land was worth. Fenlon's answer: "$10 an acre."

So F. A. Seiberling bought his sixty-four-acre island for $640, a savings of $5,460 from Hill's price. He used some of the savings to build the family's principal summer residence, Cedar Lodge, in 1900. The primary island home was almost as much of a bargain as the island itself. F. A. contracted with a man in Cheboygan,

Michigan, to cut and plane almost every piece of the house. When he had finished, the man and his three sons, all carpenters, floated the materials across the straits of Lake Huron to the island on a boat and assembled the three-bedroom house around a great stone fireplace in the living room. The house, which could accommodate up to thirty-two people, cost $2,000.

Guided by local Native Americans, the Seiberlings fished, hunted, sailed, and canoed. They also played host to the largest movable tennis competition any family could imagine. All the Seiberlings, including F. A. and Gertrude, played tennis, and summerlong competition, begun on the courts at Stan Hywet Hall, was transported north to the Cedar Lodge courts, where visiting guests would swell the number of competitors.

From their first trip to Cedar Lodge, in 1900, the Seiberlings set a pattern they would continue when they moved into Stan Hywet Hall. Key members of their household staff would accompany them to Michigan. In 1901, Cora A. Southworth made the trip to care for three-year-old Penfield and his younger sister, Virginia. It was a full-time job.

During the trip, Penny decided he should join his father, whom he adored, and his uncle Doc Chase as they started off in a rowboat to do some fishing. Penny did not yet grasp the properties of water. He stepped off a dock and tried to walk on water to the rowboat. Penny sank and began to cry. The water was shallow. So F. A. thought it should become a wet object lesson for his young son.

"Let him cry and let him get out," F. A. told those ready to come to Penny's rescue, including, perhaps, Miss Southworth, whom everyone called Aunty Southworth. "He has got to learn that the water is wet."

Self-reliance proved to be another part of young Penny's lesson. Twenty-one years later, however, it was F. A. who would display his own self-reliance hardly a week after the family had arrived for an extended stay at Cedar Lodge. He began to look ahead.

"That was when the vacation really ended," F. A. said, "when I began to think seriously on how to mend my situation."

He had one great asset: His reputation in the rubber busi-

Sundial, West Terrace

ness. Many of the calls he took in his Stan Hywet office had been from men who wanted to work with or for him again. He decided he would get back into the rubber business.

When F. A. returned to Akron that summer, his Stan Hywet Hall office again buzzed with business, and the first person he told of his plan was that former little water-walker, Penfield. F. A. wanted his son, fresh out of Princeton and eager to marry and begin a career, with him as he put together a deal to take over the Portage Rubber Company in neighboring Barberton. The Seiberlings—actually, Gertrude, in name—owned another tiny rubber company in Newcastle, Pennsylvania, one of 330 in the country in 1921. From this small start, F. A., Penfield, Charlie, and other Seiberlings built Seiberling Rubber Company over the years into the seventh largest rubber company in the world.

But even during that busy comeback summer of 1921, the

Seiberlings had time to enjoy the typical Stan Hywet smorgas-
bord of warm-weather pleasures: horseback riding (abandoned in
the mid- to late-1920s), golf on the estate's four-hole course,
clock golf on the grass circle immediately in front of the Manor
House, tennis, swimming and diving in the Lagoon (there were
two diving areas, east and west), croquet, and its more demanding
offshoot, roque.

The roque court, north of the Grape Arbor and just east of
the Birch Allee, was professionally designed, with a surface of
sand and clay. It was level and fast, demanding exact shots at es-
pecially narrow wickets embedded in concrete. It looked like an
outdoor billiard table.

"The thing that caused the roque court to be abandoned was
the narrowness and relentless solidity of the wickets," recalled
Franklin Seiberling Jr. "Even a slightly misdirected shot would
bounce off the wicket instead of going through, potentially wast-
ing two shots. Roque was simply too exacting for the easy-going
years."

Croquet better suited the times and their pace. The court,
Franklin said, was "quite casually laid out . . . but carefully grad-
ed and slightly sunken." Located north of the West Terrace, its
meticulously manicured bent grass brought to Stan Hywet Hall
not only relatives such as Doc Chase, E. A. Pflueger, and Henry
B. Manton, F. A.'s brothers-in-law, but also competitors from the
rubber business such as S. S. "Sam" Miller, chairman of the
board of the Mohawk Rubber Company.

The beauty of the estate only enhanced summer activities.
The perfect bent grass on the croquet court also could be found
on the greens of each of the four golf holes and the clock golf
surface. Roses of assorted colors sheathed the Tennis Court near
the Lagoon. The service garden parallel to the Birch Allee offered
daily cutting possibilities to Gertrude Seiberling and the garden-
ers. Urns, filled with perennials, reached their peaks of color in
early- to mid-June. Late-season moisture and cool nights would
refresh the flowers and deepen the colors.

Amid all this summer beauty, life, with its happiness and
heartache, went on not only for the Seiberlings but also for the
men and women who made up the Stan Hywet Hall staff. During

the early '20s, for instance, chauffeur Guy Graber was sent by housekeeper Anne Mahoney to pick up Kathleen Hemmings for a job interview. Hemmings had emigrated from England and was living with her sister in Kenmore. In the early years, the halcyon years of Stan Hywet Hall, at least twenty-two immigrants found work at the Seiberlings' home. They came from all over Europe, from Ireland, Switzerland, Poland, Germany, Sweden, England, Rumania, and Austria, but more of them (eight) arrived from Scotland than from any other country.

Kathleen Hemmings was one of the people for whom Stan Hywet Hall became a window to America. Hemmings got a job as an upstairs maid. As part of her duties, she was required to serve chauffeur Graber his meals in the servants' dining room. Graber often ate alone because of his irregular driving schedule, and he and Hemmings developed a bantering relationship. One day, cook William Fricker dared Hemmings to put a rose on Guy's plate. She did, and soon the two were married.

If Kathleen Hemmings found happiness at Stan Hywet Hall, Ford Bachtel came to know heartache. He served as the grounds superintendent in the late 1920s and early '30s. His brother, Howard, also worked as a gardener. Ford, who owned property on Garman Road, had married one of the Garman family, Bessie. She was a troubled woman. Hospitalized with psychological problems, Bessie Bachtel fled the facility and was found drowned in Stan Hywet's Lagoon.

Though the Stan Hywet Hall staff members weren't family, sometimes they must have wondered. The Seiberlings respected them, and even if it wasn't summer with the family away, the staff could take liberties that were not necessarily common in other great American Country Houses.

During the 1940s in the Billiard Room, for instance, F. A. came upon cook Libby Ciriack and her sister-in-law Lila Romas, the upstairs maid who often helped her sister-in-law with the dishes. The women weren't collecting dirty dishes. They were shooting a game.

No problem, F. A. told them. Keep shooting.

As the motto promised—Stan Hywet's pleasures weren't for the Seiberlings alone, in the summer or any season.

Overleaf: Cutting Garden,
View of Manor House

Daylilies, Cutting Garden

Larkspur, Cutting Garden

Cosmos, Cutting Garden

Plantings, South Terrace

Oriental Lamp, Solarium

Oriental-Style Objects,
Solarium

Detail of Silk-Embroidered
Cloud Collar, Solarium

Automatic Shuffling Card
Table, Solarium

Solarium

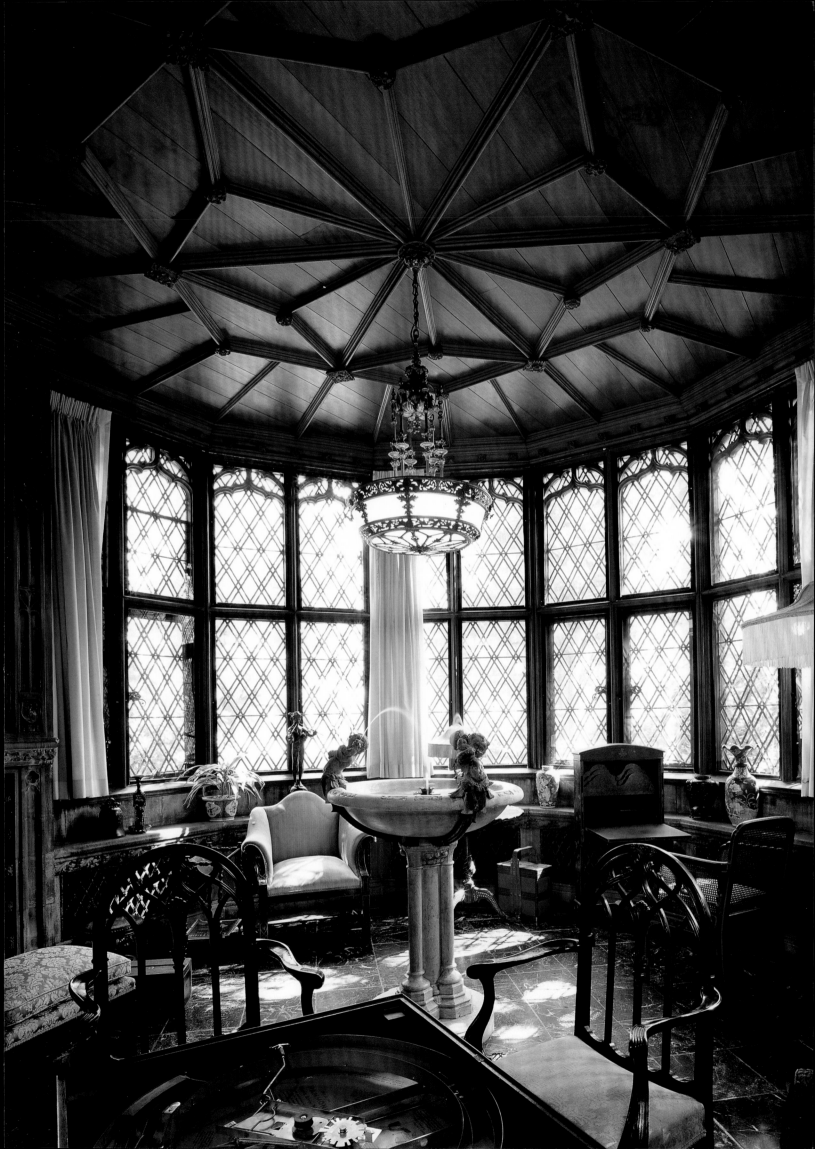

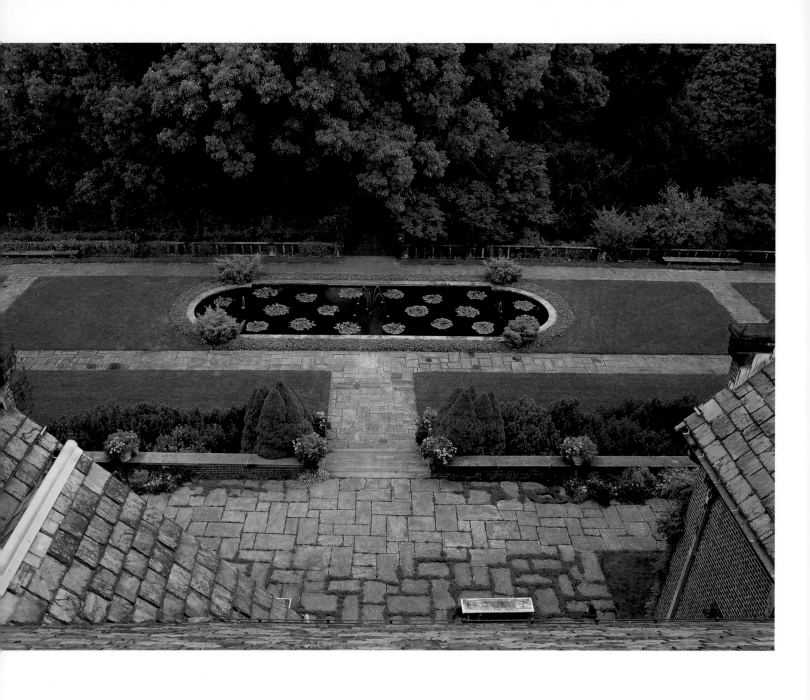

Pool, West Terrace, View from
Manor House Roof

Gargoyle on Tower, Manor House

1916 Bronze Statue of Water
Goddess, English Garden

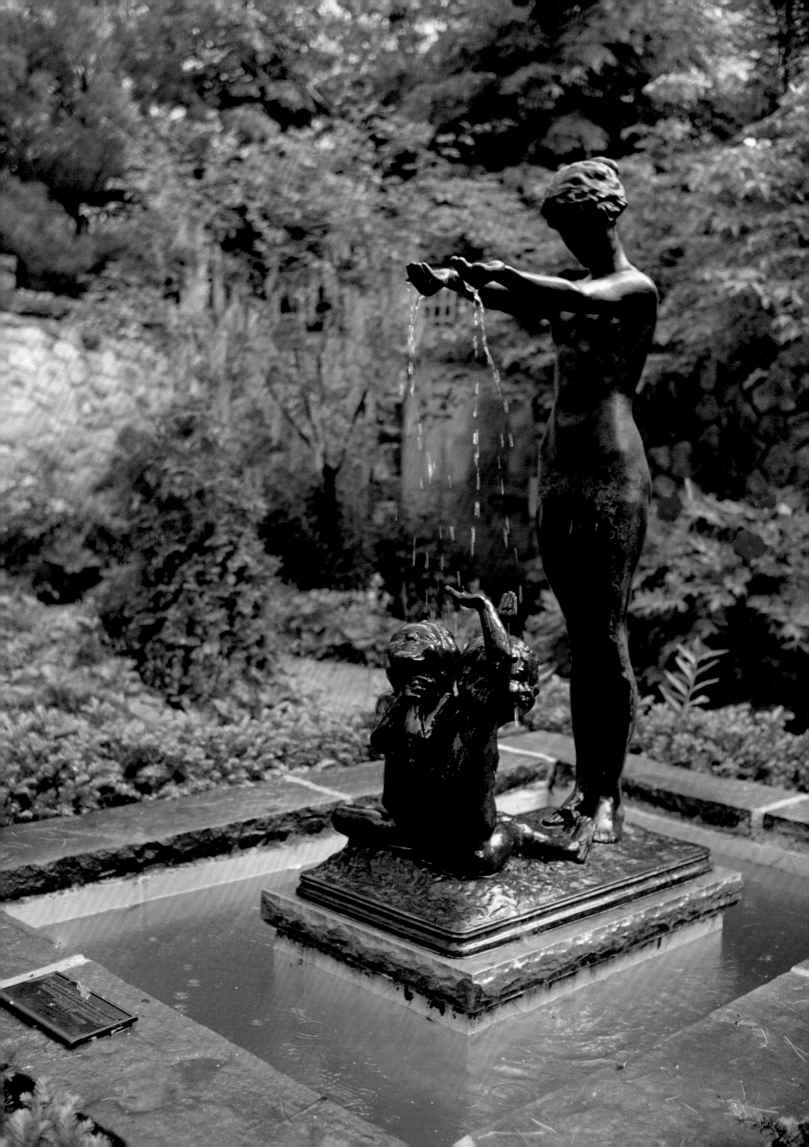

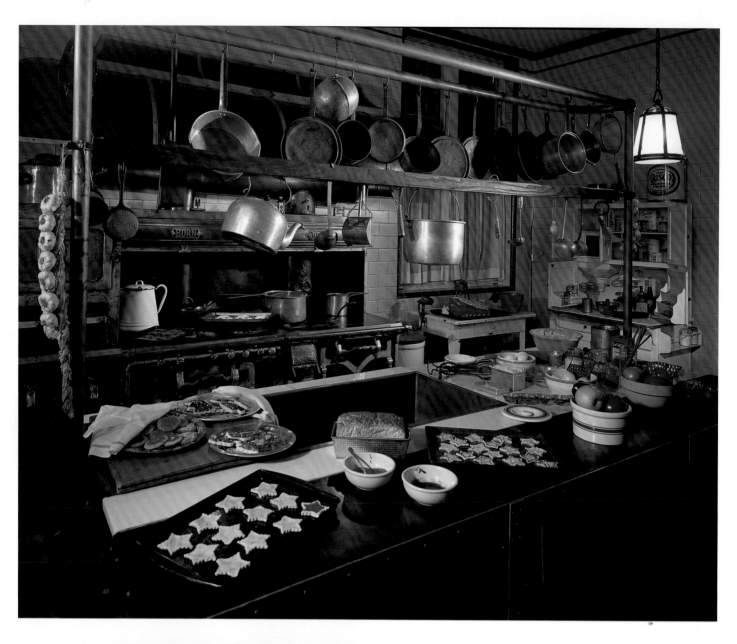

Kitchen

Fresh Floral Arrangement with Gourd, Kitchen

Climbing Roses at Entrance to Rose Garden

Detail from Rose Garden

Rose Garden, View of Manor House

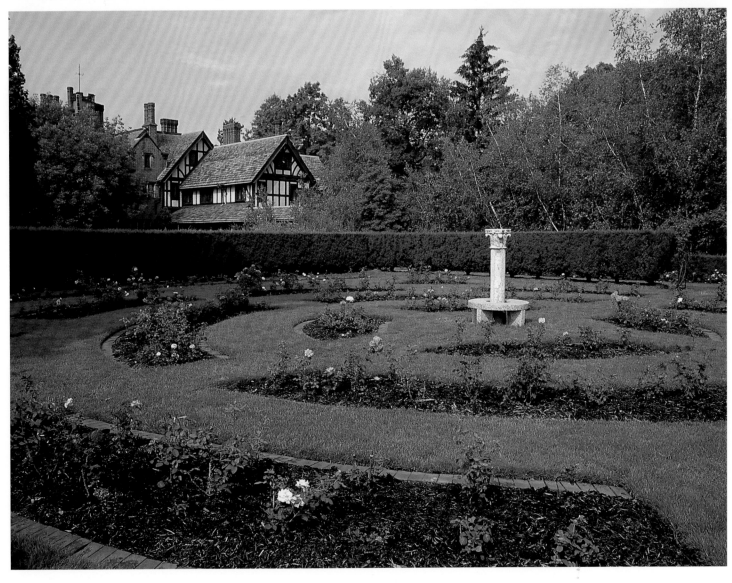

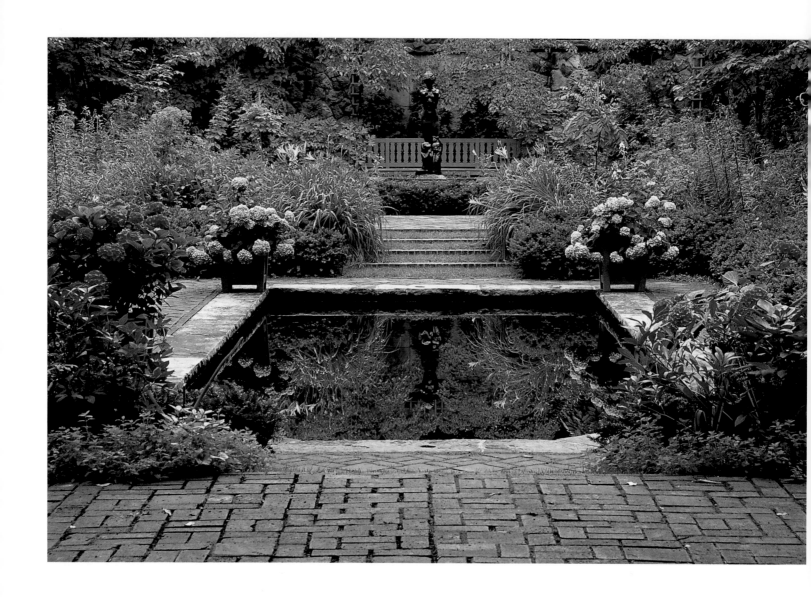

Reflecting Pool, English Garden

Ivy on Manor House Window

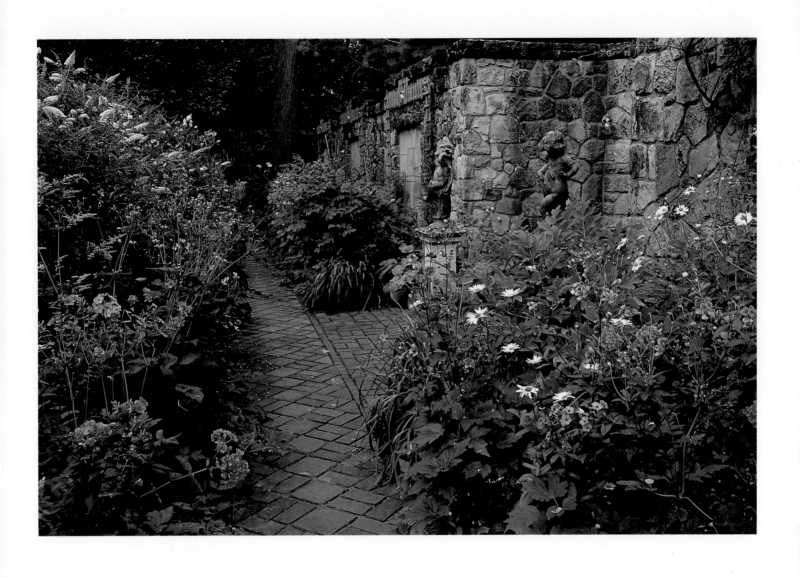

Brick Path, English Garden

View of Upper Terrace Garden

Perennial Garden below West Terrace

Tea Buffet, Dining Room

[103]

Crystal, Dining Room Table

English and American Silver, Dining Room

Dining Room Table, View to Great Hall

Chaucer's Canterbury Tales *Mural, Dining Room*

German Porcelain Dessert Plates, Dining Room Cabinet

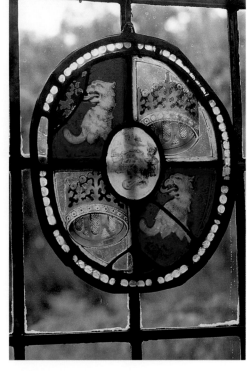

Northwest Corner, Dining Room

Window with Stained Glass Medallion, Dining Room

[107]

Weather Vane on Carriage House

Peonies, View of Carriage House

Summer Awnings on West Façade

Evening View, West Terrace

[110]

FALL

Autumn Foliage

Preserved Floral Arrangement, Adam-Style Guest Bedroom

Fall comes best and brightest to the back side of Stan Hywet Hall and Gardens. To the north, with its Lagoon. To the west, with the Dell, its foliage painted crimson and gold, the lowering sun streaming through the branches of the hardwood trees, creating a feeling that the visitor is looking through a giant stained-glass chapel window.

In the first week of October in 1919, Gertrude and Frank A. Seiberling did, in fact, transform the Dell into a chapel. There, they would play host to the second wedding to take place at their nearly four-year-old American Country House estate. Their baby girl, Virginia, newly graduated from Westover finishing school in Middlebury, Connecticut, was marrying John Littlefield Handy.

It was an occasion and a season of change.

Summer to fall. Adolescence to adulthood. Single to married. Sea changes, one and all. Octobers were like that at Stan Hywet Hall. On this particular Saturday, October 4, Ginny Seiberling's wedding would become one of the "prettiest and most elegant" to take place in Akron in many years, according to the *Akron Beacon* society page.

Guests assembled on the Stan Hywet Hall grounds at 3:00 p.m., an hour before the ceremony. As they were guided to the Dell, southwest of the house and just across Pleasure Drive, Johnson's Orchestra from Cleveland played. The Dell was ready. Its natural beauty, as landscape architect Warren H. Manning suggested, needed little help.

Guests walked through oaks, tulip poplars, and maples to reach the Dell. On the perimeter, dogwoods contributed the deep red of their leaves to the yellow of the maples. Barberry, bittersweet, and some flowering shrubs added their own hues, including hints of orange.

The Dell, for all its own regal splendor, had additional help from Hugo F. Huber, Stan Hywet Hall's interior decorator. Huber designed floral arches and bows that were placed in the Dell. Since there were no pews in this outdoor chapel, wedding guests

stood behind garlands of bittersweet and dried leaves that the Stan Hywet Hall staff had collected in the woods to separate the guests from the wedding party.

Harriet Manton, who would become Ginny's sister-in-law, marrying Penny, in 1923, served as Ginny's maid of honor. Four school friends from Westover were bridesmaids. Ginny—that's what everyone called her—wore a wedding gown appraised at $10,000, according to family oral history. That would have been equivalent of more than $100,000 in the final years of the twentieth century. However, when the gown was appraised in 1993, it was valued at $1,500, and a gemologist determined the "pearls" were actually manmade.

Ginny and Jack Handy were beginning a new life together. It would be a marriage that would prove growing up in a family with money and a big house does not guarantee a person will live happily ever after. Conversely, the season had the feeling not of a beginning but an ending. Fall's smell filled the air—a crispness, with a hint of burning leaves.

Fall at Stan Hywet Hall is a time for shutting down, for feeling as if a season of labor has come to an end and rest is nigh. Leaves fall and are left to lie in the woodlands, with nature, as Manning had intended, taking its course. To those leaves the grounds staff adds piles and piles of rakings from the Great Meadow and other lawns near the house.

When the moisture has been adequate, the nights cool, the days hanging onto a hint of summer's warmth, staff and family alike could walk out on the West Terrace and, from there, to its overlook or across the north lawn and down to its culminating vistas. There before them, across the Cuyahoga Valley, spread a picture in yellow, gold, red, and brown, an Ohio hardwood landscape scene.

With winter's rest ahead, the estate had to be tucked in. Plants to be saved were removed from urns on the West Terrace and elsewhere outside and transported to the Palm House, the front section of the Conservatory. Some of Stan Hywet Hall's larger houseplants also were removed to the Palm House or exchanged with plants there—palms, of course, bay trees, fig trees.

The Palm House provided more than winter protection for

plants. It also offered winter solace to the family members. It was designed so that it could be a winter retreat, a place to come and wander among the orchids and other exotic flora.

Before Thanksgiving, which the Seiberlings generally celebrated by going to the home of F. A. Seiberling's sister, Mary Manton, the grounds staff would drain the waterlines and winterize the fountains and pools. The urns would be cleaned and wood would be gathered or cut and stored for the winter. A wood-storage room was built into the basement below the Solarium, a lift carrying firewood to the main floor. To supply twenty-three fireplaces requires more than a rick or two of hardwood.

It probably wasn't cold enough on October 11, 1917, to light

West Overlook

fires in Stan Hywet Hall's fireplaces for the first wedding held in the house. But there was a glow in the Music Room nonetheless. Lt. John F. Seiberling, the eldest Seiberling son, had come home from a year of army service on the Mexican border in El Paso, Texas. There he had met Henrietta McBrayer Buckler, daughter of Judge and Mrs. Julius Buckler, a prominent El Paso family. Among Henrietta's attendants at her wedding were Ellen Thomas of Augusta, Georgia, Virginia Seiberling, and Irene Seiberling, the maid of honor who six years later would also marry in the Music Room.

Yellow chrysanthemums and maidenhair fern adorned the recesses of the Music Room. From the balcony, Evan Williams and Mrs. T. S. Eichelberger sang as James H. Rogers of Cleveland played on the organ below. At the opposite end of the Music Room, an altar stood before palms and tall ferns.

Two clergymen stood behind the altar to perform the ceremony witnessed by 280 people: Rev. E. W. Simon of Trinity Lutheran, the Seiberlings' church, and Rev. J. Sproule Lyons of First Presbyterian Church in Atlanta, a representative of the Buckler family.

Rev. Lyons was impressed not only by John "Fred" Seiberling's devotion to Henrietta—a devotion that Lyons saw as "beautiful and profound"—but also by Stan Hywet Hall and the family that lived there.

The fall panorama swept Lyons away with the singular quality that Manning had sought to impart: naturalness. "It is situated," Lyons wrote of the home, "in a glorious park, surround by hundreds of acres made as beautiful as can possibly be [by] natural advantages, aided by skillful landscape gardening."

The money the Seiberlings had invested in Stan Hywet Hall was not lost on the clergyman, but what he sensed in its rooms and hallways, its nooks and crannies had more to do with the spiritual than the secular. Lyons stayed in the Della Robbia Room, with its Florentine-style decor, the Tower location where eleven months later Henrietta would give birth to her and Fred's first child, John F. Seiberling Jr.

"It is difficult to see how so much money could be spent in the very elaborate finish and decoration," Lyons wrote, "without

the whole appearing formal and cold. On the contrary, it is free from any such impression. . . . It is primarily and emphatically a home."

If Lyons could see clearly the kind of place Stan Hywet Hall was, his prediction for Fred and Henrietta's marriage proved less prescient. "I am certain," Lyons concluded, "they will have a happy life together." They didn't—at least not always.

Both October marriages—Fred and Henrietta's, Ginny and Jack Handy's—were troubled. Fred and Henrietta separated in 1935, with Fred moving from the Gate Lodge, where the family had been living, to the Manor House. He lived there until after Stan Hywet Hall was turned over to the Stan Hywet Hall Foundation. Henrietta moved to New York City in 1944 but, until 1952, spent summers at the Gate Lodge.

Japanese Maples,
View from West Terrace
Balustrade

No one foresaw problems for Fred and Henrietta. That wasn't, however, the case when Ginny married Jack Handy. Ginny's brother, Willard, opposed the marriage. He had misgivings about Handy, which he expressed in a long letter to his sister while she was still at school at Westover. As she responded to Willard, Ginny's rage at his interference seeped through despite a fierce restraint. As difficult as it must have been, Ginny determinedly sought to maintain the close family relationship that the Seiberling children had been taught from childhood to nourish.

"I don't believe love can be figured out and analyzed and picked apart," Ginny wrote to her brother. "Nor do I think you can set a time for one to fall in love."

Love is not like the seasons. It does not come in October, as fall does to Stan Hywet Hall.

"Time will tell who is right on this wedding question," Ginny wrote to Willard. As it turned out, both she and her brother were right.

In another October, the October of 1937, there was a celebration at Stan Hywet Hall of a Seiberling marriage that had held steadfast for fifty years. In the concluding event of a three-day extravaganza, five hundred people gathered at Stan Hywet Hall on October 12 to acknowledge the love that F. A. and Gertrude Seiberling had for each other and to share with the couple a love of their own.

F. A. Seiberling was overcome. "Material accumulations," he said, "are insignificant compared with the value of friends."

As the Seiberlings' friends and family wound their way up the estate drive that Tuesday evening in October, they were greeted with the golden hues not only of the anniversary celebration but also of the season. Through the apple orchard and across the Great Meadow, they could see the backdrop of large maples and great oaks. When Carl Ruprecht, who for years protected and cultivated the Seiberling-Manning landscape legacy, came upon this view, he always had the same thought: "You've made the harvest. It is time to enjoy it."

In the Manor House that night, F. A. and Gertrude Seiberling enjoyed, as perhaps they never had, the rewards of the life they had built together. Two days before, the Seiberling grand-

children had put on a program that included songs, monologues, skits, and short plays, all celebrating their grandparents. On this final night, nationally famous tenor James Melton and the Teslof Singers, led by Jean Teslof, performed, following a reception organ recital by Katherine Bruot.

When the guests had been seated in the Music Room for the evening's main program, the Seiberlings entered through the Round Room to a standing ovation—and to some advice. Because so many had come to celebrate with the Seiberlings, the aisle to the front of the Music Room had been squeezed down to a width of one. Someone told F. A. that he would have to follow Gertrude.

Detail, Mrs. Seiberling's
Writing Desk, Master
Bedroom

"All right," F. A. said, nonplussed. "I've been following her for fifty years."

Many people from the rubber industry were in the room that evening, including J. A. "Jack" MacMillan, chairman of the Dayton Rubber Company. "Mrs. MacMillan and I have known the Seiberlings for years, have been weekend guests in their home. We love them," MacMillan said. "I told F. A. I'd go across the continent to be there for his wedding anniversary."

For those who traveled not across the continent but into the late fall of the Seiberlings' lives, F. A. and Gertrude expressed their appreciation: "We have traveled together for fifty years," F. A. said. "I won't tell you everything that has happened down the road, for there are some dark spots, [but] I feel deep gratitude to you who have come here tonight."

Before the fiftieth-anniversary celebration, Penny Seiberling had expressed concern to his sister, Irene Seiberling Harrison, about the "scope and extensiveness" of a moment that he thought should be a "more or less intimate and personal event between two parties as distinguished from birthdays which record the passing of time. . . . Wedding anniversaries, by their very nature, involve or should involve personal sentiments, memories and incidents that are hardly the subject of 'town meetings.'"

Penfield, who succeeded his father as chairman of Seiberling Rubber Company, changed his mind that night or sometime thereafter. In 1974, he wrote that "Mother and Father's Fiftieth Golden Wedding Anniversary celebration at Stan Hywet Hall was, without question, the most memorable event of their lives and, in my judgment, the loveliest memory that I have of them in connection with their life at Stan Hywet."

The Seiberling marriages begun or celebrated in the autumns of Stan Hywet Hall were neither more perfect nor less perfect than others. The marriage of F. A. and Gertrude lasted more than fifty-eight years. That of Fred and Henrietta Seiberling ended in separation. That of Ginny and Jack Handy had many of the "dark spots" that even F. A. Seiberling acknowledged in his own marriage but, in the end, held fast.

Ginny died in 1971 and Jack in 1980. Both were cremated and buried in Vermont, where they had been living at the time of Gin-

ny's death. In 1995, Jack and Ginny's remains were reburied in the Cummaquid Cemetery about a mile from the Handy compound in the village of Barnstable, Massachusetts.

It was a moment with roots in the fall of 1919 at Stan Hywet Hall.

The Handys' descendants put Jack and Ginny to rest next to Jack's father and with a long line of Handys and other ancestors. At this closing moment for two lives shared, they wanted to remember and recognize Stan Hywet Hall, where it had all begun on an October day so long ago. So onto the Handys' graves, they sprinkled spoonfuls of dirt.

It wasn't just any dirt. It was from the Dell.

Birch Allee, View to North Porch

Overleaf: Lagoon

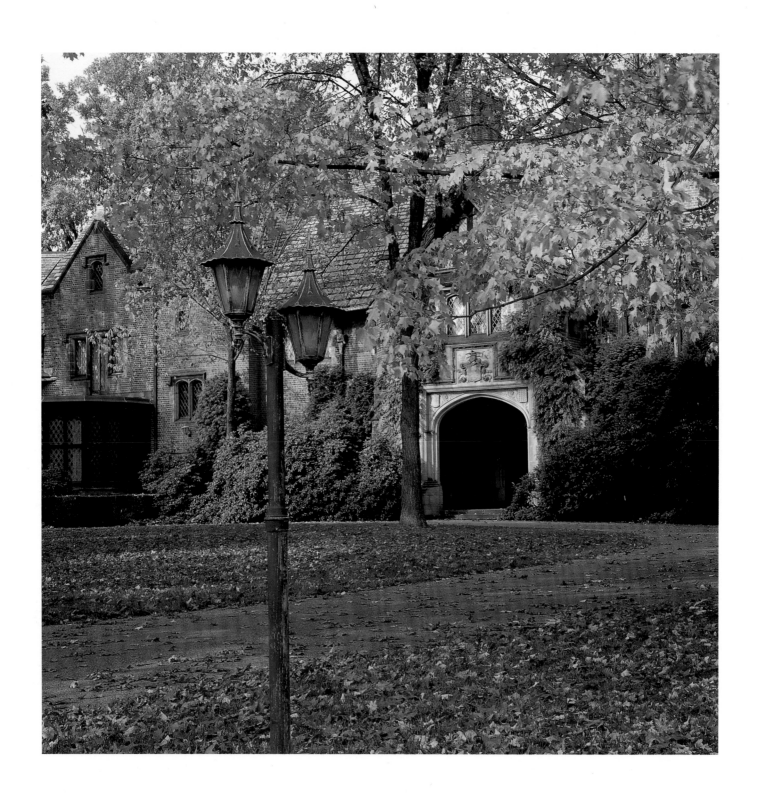

Main Entrance, Manor House

West Vista from Great Hall Doorway

[126]

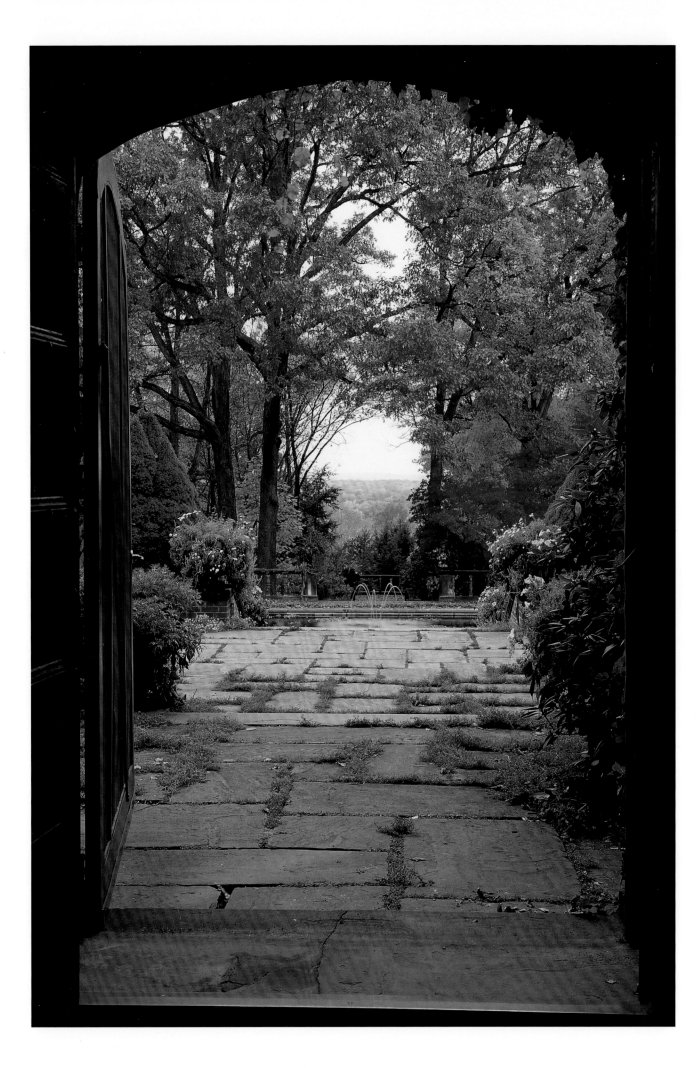

Boston Ivy Fruit along West Terrace Balustrade

Autumn Reflection in West Porch Window

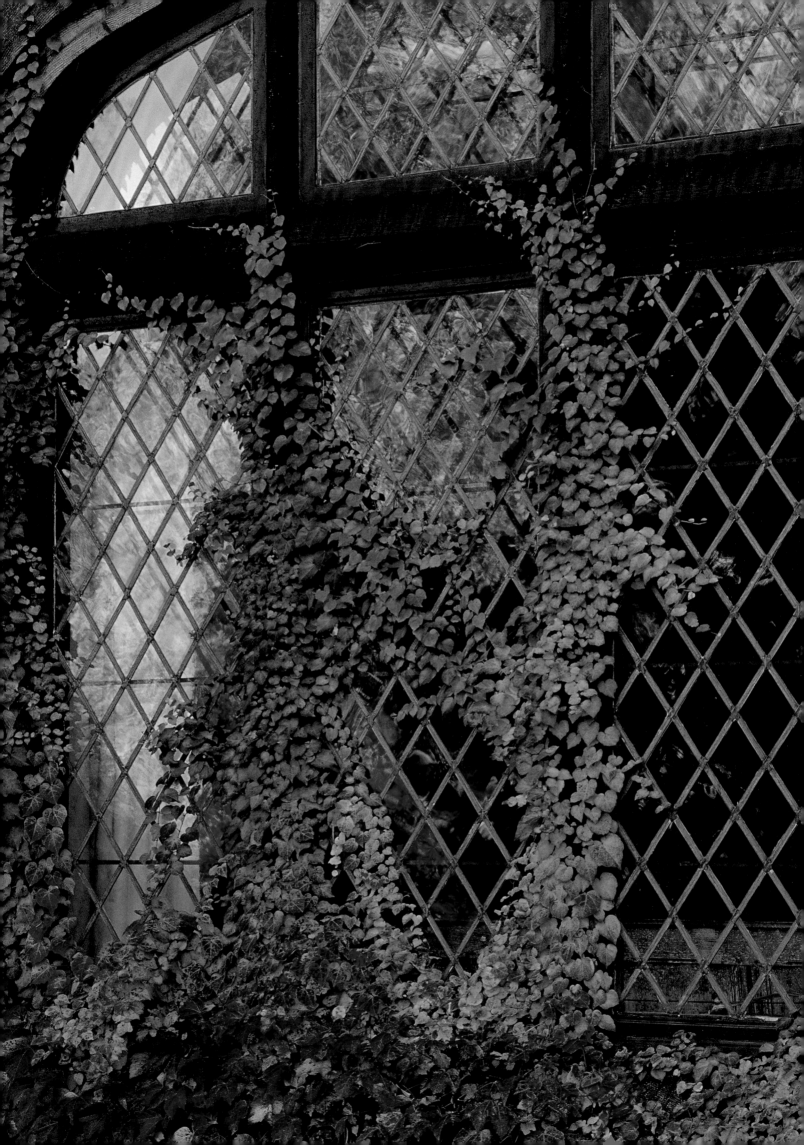

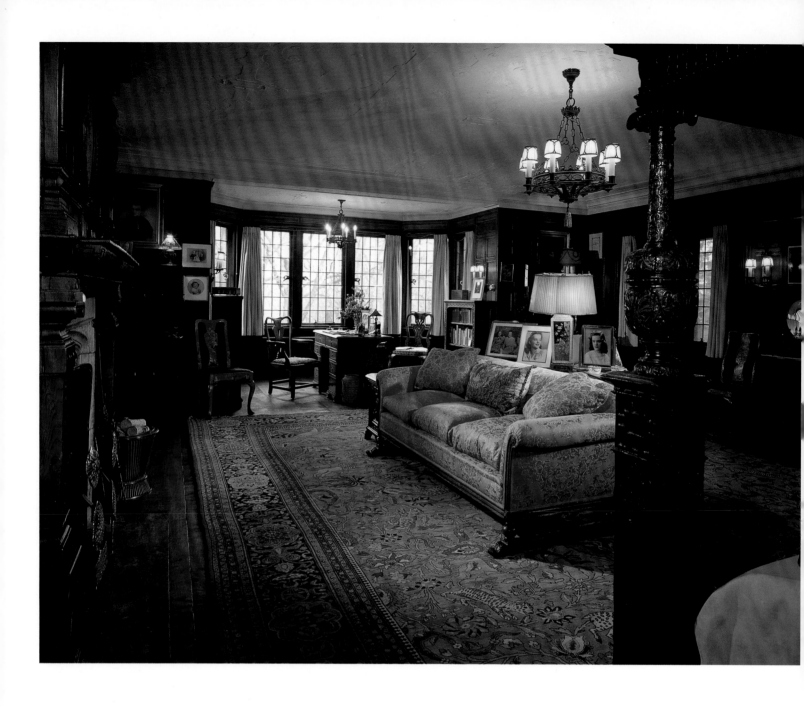

The Master Bedroom

Bookshelf Detail, Master Bedroom

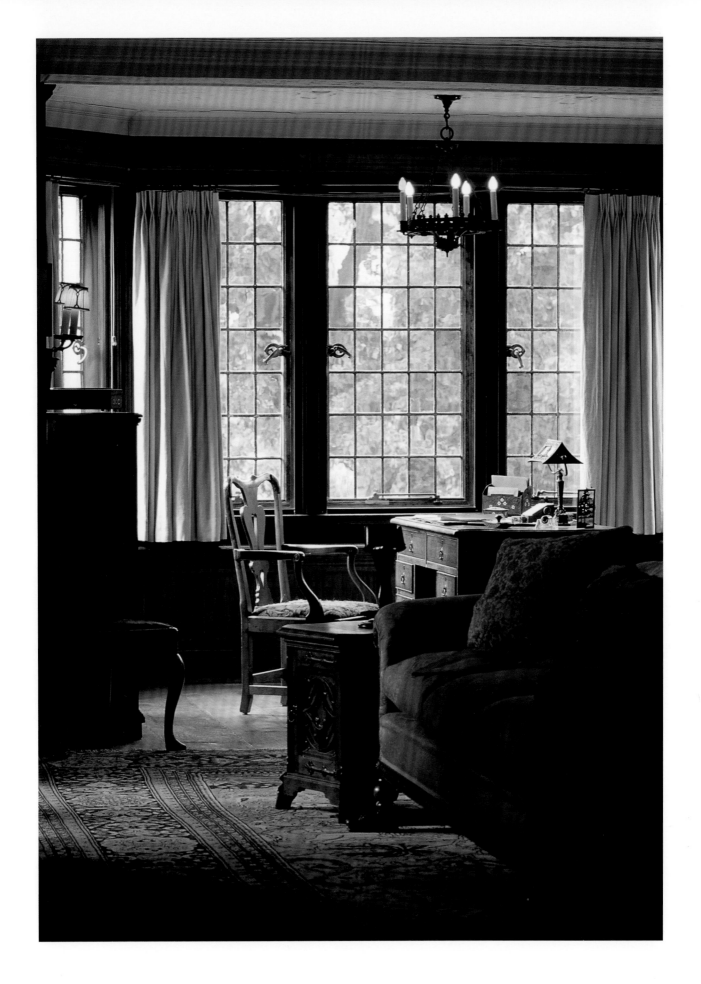

Mrs. Seiberling's Writing Desk, Master Bedroom

Pedestal Sink, Mrs. Seiberling's Bathroom

Needle Shower, Mr. Seiberling's Bathroom

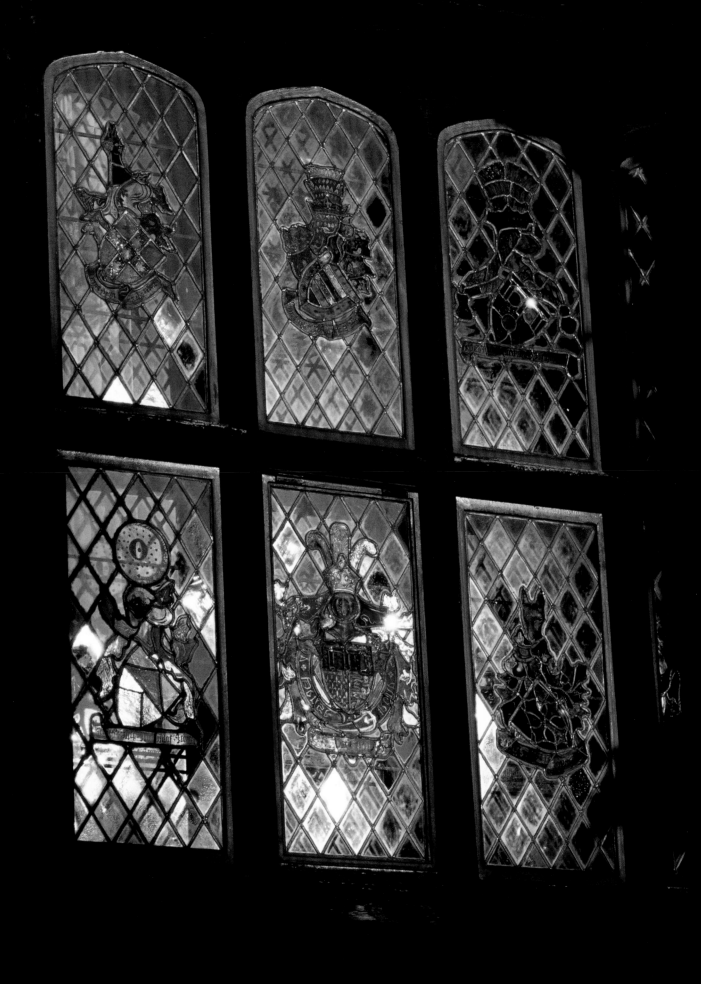

Exterior Detail, West Porch

Alcove Windows, Great Hall

[135]

Autumn Leaves on Lagoon

Boston Ivy, West Terrace Wall

Duckweed on the Lagoon

Lily-of-the-Valley and Periwinkle, Birch Allee

Footbridge, Lagoon

Cistern Door near Japanese Garden

Misty Morning, Great Meadow

Seasons Statue of "Spring," South Terrace

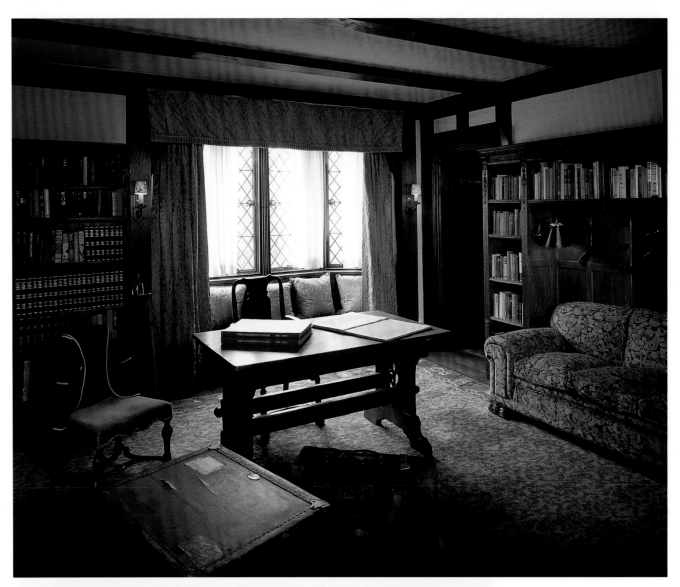

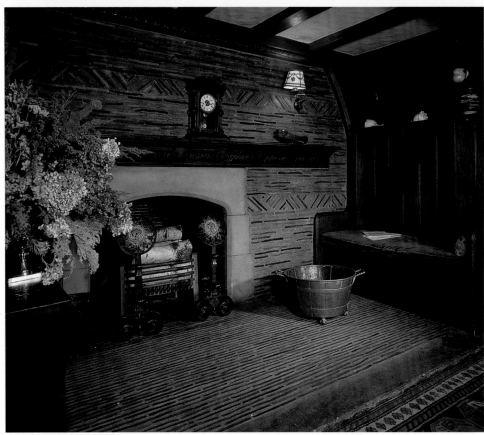

Boys' Blue Bedroom

Inglenook, Boys' Blue
Bedroom

Irene Seiberling's
Bedroom

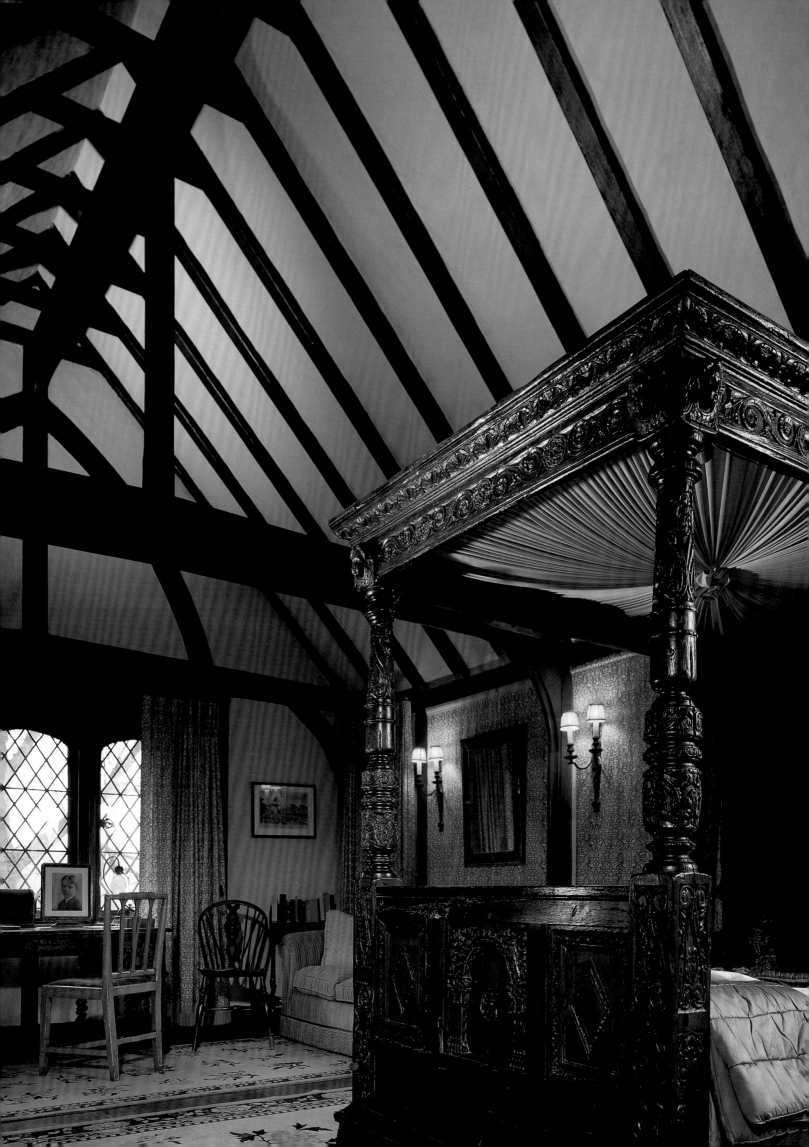

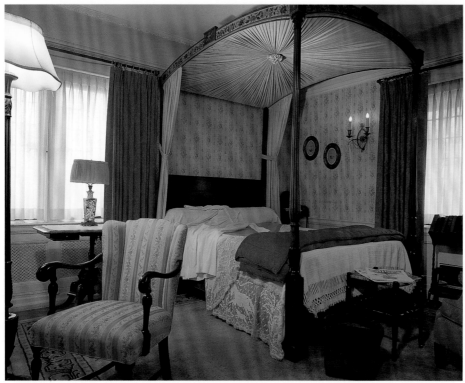

*Adam-Style Guest
Bedroom*

*Colonial-Style Guest
Bedroom*

*Franklin Seiberling's
Bedroom, View from
Sleeping Porch*

William and Mary-Style Guest Bedroom

Suitcase, Adam-Style Guest Bedroom

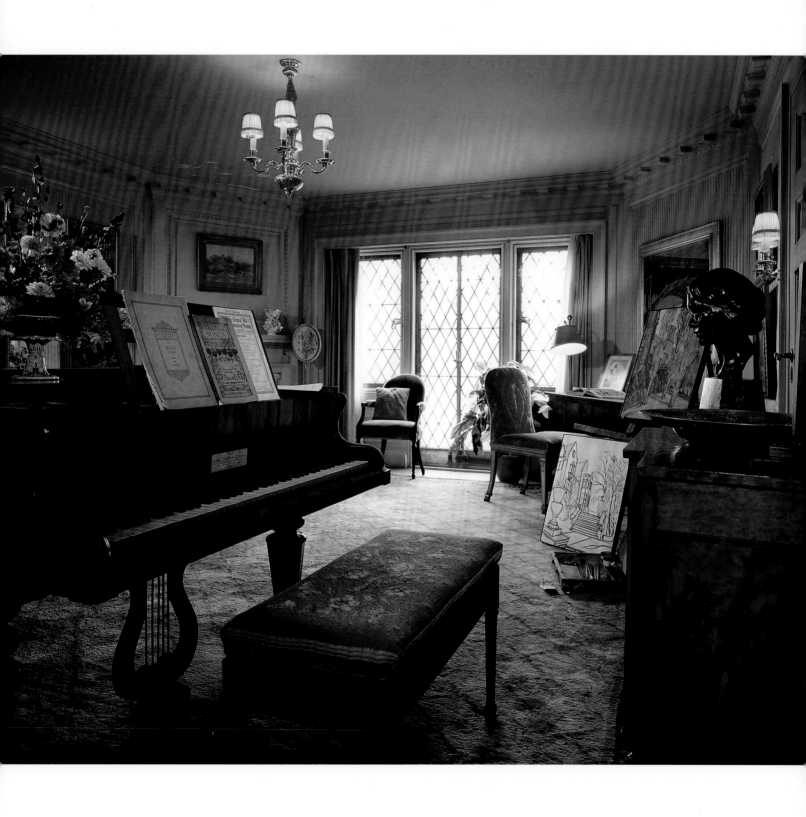

Mrs. Seiberling's Morning Room

[145]

Pool, West Terrace

WINTER

Viburnum Berries

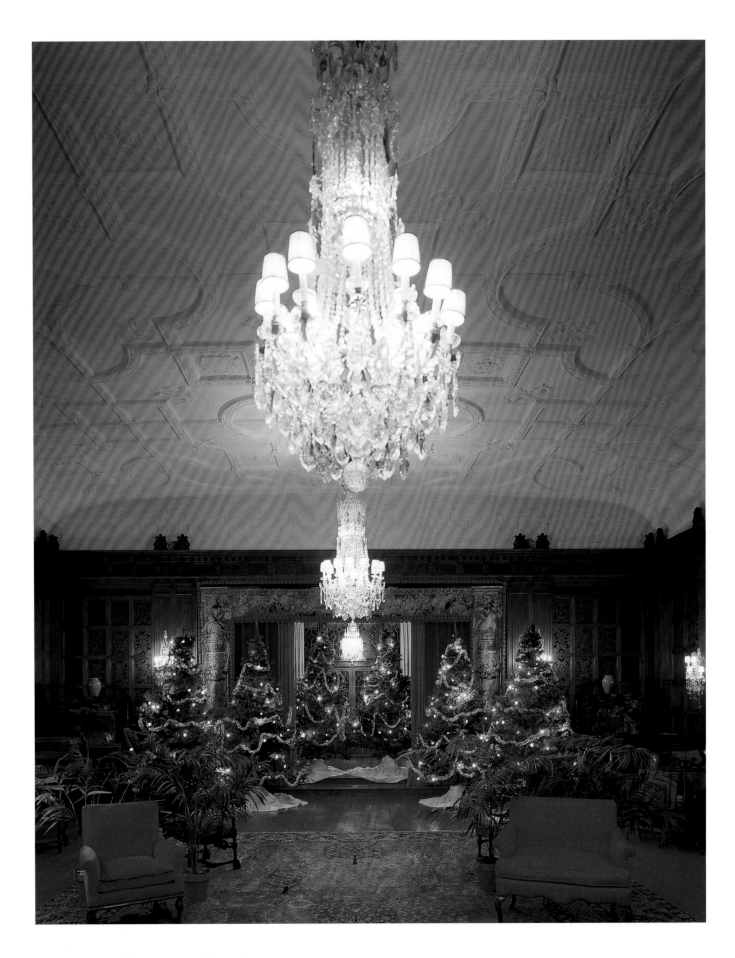

Christmas 1998, Music Room

S tan Hywet Hall was made for Christmas, the home becoming a stage on which the Seiberling family played out Dickensian scenes. The characters—and some of the Seiberlings *were* characters—came from far and wide. They were large and small, young and old. They came by train. They came in those newfangled automobiles on which the Seiberling fortune rode. They came early, sometimes days before Christmas, and they rose early, so as not to miss a moment of the magic.

The brightest of these family days began in the dark. Some years, Christmas started at a midnight service at Trinity Lutheran Church. Other years, years that imprinted themselves on the minds of children and adults alike, Christmas day began when all through the house not a creature was stirring—except for Gertrude Seiberling.

Christmas always began with Gertrude.

The tradition, like so many in the family, was carried from the former Seiberling home on East Market Street and put in place at Stan Hywet Hall, as if it were more precious than the family's Haydn harpsichord. The Seiberlings loved old things. But they loved their traditions even more.

If the deep meaning and importance of the Seiberling family Christmas sometimes escaped F. A. Seiberling the businessman, it was brought home to him during December 1898. The first week of that month, little eight-year-old Irene Seiberling had pulled the cord that sent electricity surging through the machines with which the Seiberlings' new company, Goodyear, would make rubber. The first carriage tires had come off the line. The season was filled with joy. Then, two days before Christmas, F. A. picked up his newspaper and read of a court decision that could ruin his fledgling company before it got started.

Edwin S. Kelly's Rubber Tire Wheel Company in Springfield, Ohio, had won a lawsuit that gave it the patent rights to the method for making carriage tires. Goodyear needed a license.

F. A. had to go to Springfield immediately, on Christmas Eve. More than Christmas could be ruined if he didn't.

F. A. couldn't tell his wife, or his mother and father, who lived next door, why he had to make this untimely trip. He didn't want to ruin their Christmas. Yet he knew he might. Missing Christmas was a high crime in the Seiberling family. The miracle of that Christmas was that Seiberling made it home in time for the family's most important event of the year, without the license but with the determination to invent an alternative to the Kelly method. F. A. had to get home pretty early, though, to be into Christmas before his wife.

Years later, Gertrude Seiberling's habits hadn't changed. With Stan Hywet Hall wrapped in the arms of darkness, save for the flickering embers in the Great Hall fireplace, Gertrude would begin her Christmas morning rounds. Sometimes, she had gotten only a couple of hours sleep. Preparation for Christmas at Stan Hywet began six weeks in advance and could last until the wee hours of the day itself. There were favors, often small bags of home-baked cookies, to put together for the season's visitors to the home. There was a play to be adapted and rehearsed for the holiday entertainment. All of the children would have a part. There were menus to plan and discuss with the cook. Decorations had to be made and placed. It could be tiring. But fatigue vanished when it came to family. By 5:00 a.m., Gertrude would be padding up and down the second-floor hallways, rapping on each wreath-decorated door as she passed.

"Merry Christmas," she would call out.

From Irene's room to the Blue Room, where the boys stayed in a double suite, to the Colonial Room, which Ginny liked even better than her own room after she had grown up, voices shaky with sleep responded.

"Merry Christmas, Mother."

The best day of the Seiberlings' year had begun, a day filled with sharing not only gifts but also themselves. As Seiberlings of all ages scrambled out of bed, the Stan Hywet staff already had set about making Christmas memorable. Wood added to the embers in the fireplace had burst into roaring flames, casting a warm, golden glow over the Great Hall. Descending the stairway, the

family would find cups of wassail or cocoa awaiting. Soon, everyone was bundled in winter coats and standing in the crisp, clear darkness of early morn, waiting for the cars that would carry them to church. In the sky, Venus, the Christmas star, sparkled. It felt like the Star of Bethlehem. No one spoke.

It was still dark when the cars arrived at the church. Candles gave off a welcoming flicker, the only light to be seen until dawn crept into the sanctuary through stained-glass windows. The minister spoke briefly. This was a day of hosannas. The choir, dressed in vestments, transported the service to another place, to a stable in Bethlehem where the Christ child was born. The highest note of the service was the penultimate song, "Where Is the King, Oh Where?" In her sweet contralto voice, Gertrude asked the question each Christmas. The answer came as the choir strode down the aisle of the church, each member carrying a candle and singing, "Joy to the World, the Lord Has Come."

As the service ended, the Seiberlings joined other worshipers outside, sharing Christmas wishes. Though he would accompany the family to Christmas services, F. A. Seiberling never joined the church. When he was thirteen, he told his father that he couldn't join because he didn't believe, as the Lutherans did, that those of other faiths were condemned to hell.

"When I can find a church that has the golden rule as its creed, I'll join," F. A. would say.

Because F. A. lived by that golden rule, Irene Seiberling described her father as "one of the greatest Christians I ever knew or could imagine." So he could comfortably join the church members as they left the candlelit sanctuary and stopped at Westgate, the home of his sister, Mary Manton, for breakfast or returned to the Stan Hywet Hall's Breakfast Room that so many of the family members loved and in which they shared delights even on the most ordinary of days.

As the cars turned off of North Portage Path and rolled onto the Stan Hywet driveway between apple trees glistening with lights, they were greeted by lighted messages—Peace on Earth; Good Will to Men—inside and out. Another Gertrude Seiberling touch.

In the Great Hall stood a tree so tall that decorations had to

be placed on its upper branches by leaning over the Great Hall balcony and reaching out with ornaments hung on the end of a fishing pole. Family and staff would gather, and through the home's front door would come one of the Seiberling draft horses dragging the Yule log, a great piece of wood that would burn in the fireplace for what seemed hours. When it was in position, Gertrude would explain the early English tradition of tossing berries and cones into the fire so these small offerings would lead to a new year of plenty.

Following the Yule log ceremony, the staff members, who received Christmas bonuses, would give the Seiberlings small presents that invariably touched their employers. The staff was not family, but the relationship was something different, deeper than employer-employee.

Though there is plenty of sleigh landing and parking space on Stan Hywet Hall's flat roof, Santa Claus didn't use the chimney. Most often, the bells on his suit could be heard in the corridors of the second floor before Santa descended the stairs. One year, however, the jolly old fellow, who usually was played by Willard Seiberling, but sometimes by older brother Fred, turned his entrance into a performance long remembered.

Santa Fred grandly entered the Great Hall by sliding down a rope tied to the balcony. The rope broke, however, and Fred fell onto a prized antique Venetian glass candlestick, which also broke. Since the entrance was not a crashing success in the intended sense, it wasn't repeated, but the children could appreciate how a planned performance could go awry. Before they received their presents from Santa each Christmas, they were required to recite a poem, share a happy experience from their lives, or otherwise give a performance.

"Christmas was always rather overwhelming," remembers John F. Seiberling, who spent his childhood in his grandparents' home and on the estate.

Yet even on those rare occasions when the required performance overwhelmed a child and brought tears, Santa would praise and encourage the child and reward him or her with a present. Such lessons were part of growing up a Seiberling.

With as many as four generations of the family filling the

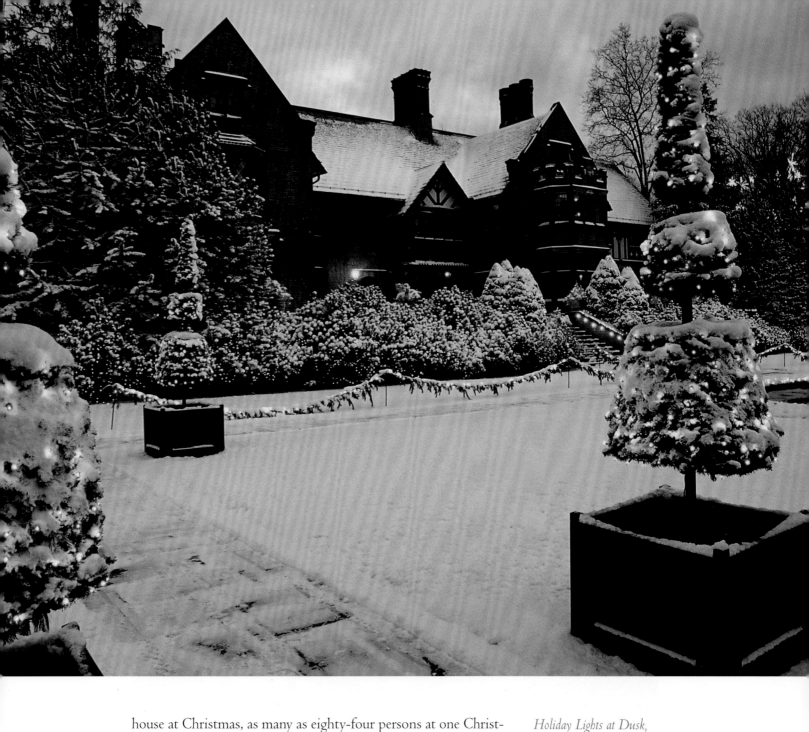

house at Christmas, as many as eighty-four persons at one Christ-
mas, F. A. Seiberling was able to offer his children and grandchil-
dren not only the obvious gifts but also those that wouldn't grow
old and obsolete but would serve them throughout their lives.
The youngest children, those under three, would take Christmas
dinner in the Breakfast Room, along with their nurses. The three-
to eleven-year-olds would fill the north corridor leading to the
Breakfast Room, sitting at long tables set up for the occasion.
The moment belonged to the twelve-year-olds. They would be
invited to join the adults in the Dining Room.

It was, remembers Julia Shaw, daughter of Willard and Mary
Seiberling, "a rite of passage" to be allowed to sit at "the big

Holiday Lights at Dusk,
West Terrace

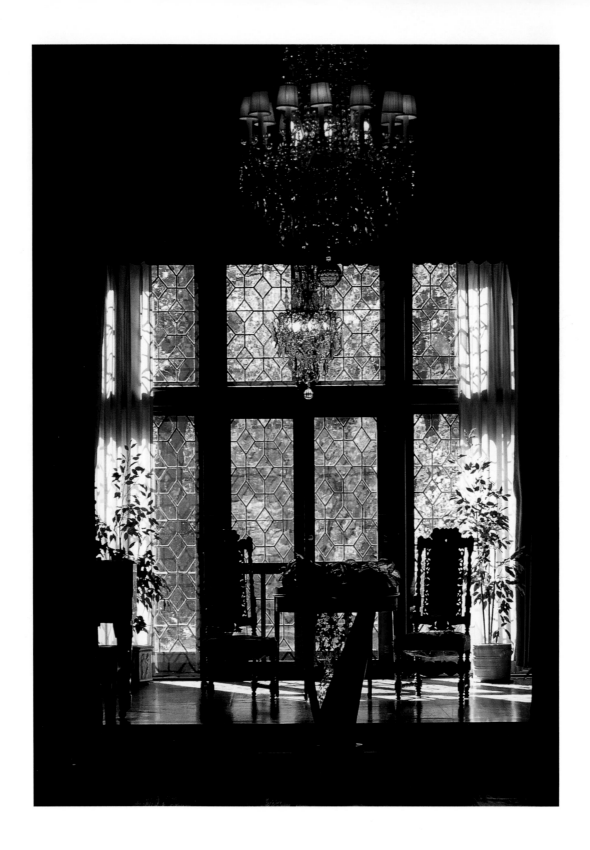

Music Room Stage

table." With passage came a price. Again, the young Seiberlings were to speak, to tell the older family members what had happened in their lives since last the family gathered, how they had changed, how they had grown. With the price came a reward: No longer children, they could partake of the after-dinner adult conversation. Listening. Learning. Growing even more.

The culmination of Christmas followed dinner, usually around 4:00 p.m., when Gertrude ushered the family into the Music Room. There, they would become the Seiberling players, taking to the small stage at the far end of the room and rendering tribute to Gertrude and such magical storytellers as Charles Dickens. One of the more unforgettable Christmases occurred when the Seiberling players performed their version of Dickens' *A Christmas Carol.*

Some Christmases would be more memorable than others: John F. Seiberling's first, with his father Frederick still in Europe, serving in World War I; the post-Christmas tea dance "Granny Sei" put on for granddaughters Mary Gertrude Seiberling, Dorothy Buckler Seiberling, Julia Gage Seiberling, Marion Otis Handy, and Sally Anne Harrison in 1940; Ned Handy's unexpected appearance in 1945 after the U.S. Air Force bombardier had been a prisoner in Germany during World War II; the announcement in 1947 of Julia Seiberling's engagement to John Shaw.

"The atmosphere," says John L. Handy Jr., "was one of unlimited joy, love, fraternity, mutual enthusiasm, high spirits, openness, and a kind of Dickensian magic that inspired us all."

As wonderful as the Christmas of 1945 was, because it was the last that all the Seiberlings were together, thirty years of Stan Hywet Hall Christmases can be captured in the memory of Sally Harrison Cochran, who could not wait each year to return to Akron from Bronxville, New York, with her mother, Irene, her father, Milton, and her siblings, Gertrude and Robert. The Harrisons would disembark from the train at Union Station in downtown Akron and be driven to Stan Hywet Hall, there to be greeted by snow glistening in the moonlight on the apple trees.

Sally Harrison didn't expect to be a part of Stan Hywet Hall Christmases for most of her life. She left one Christmas as a young woman, thinking she'd never see those lovely apple trees in the snow again. She was wrong. She returned to live in the Gate Lodge and care for her mother through her dying days.

During her mother's last Christmas, in 1998, Sally Harrison once again saw newly replanted apple trees glistening with the tiny white lights of Stan Hywet's most unforgettable season.

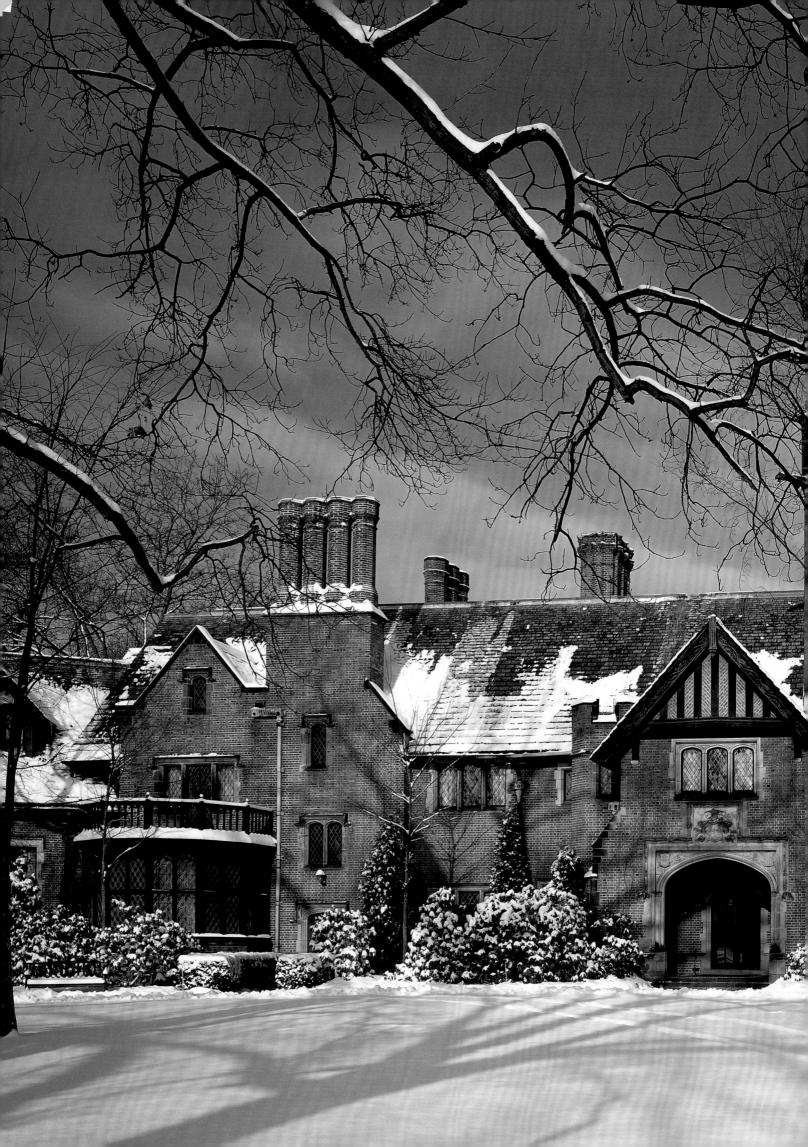

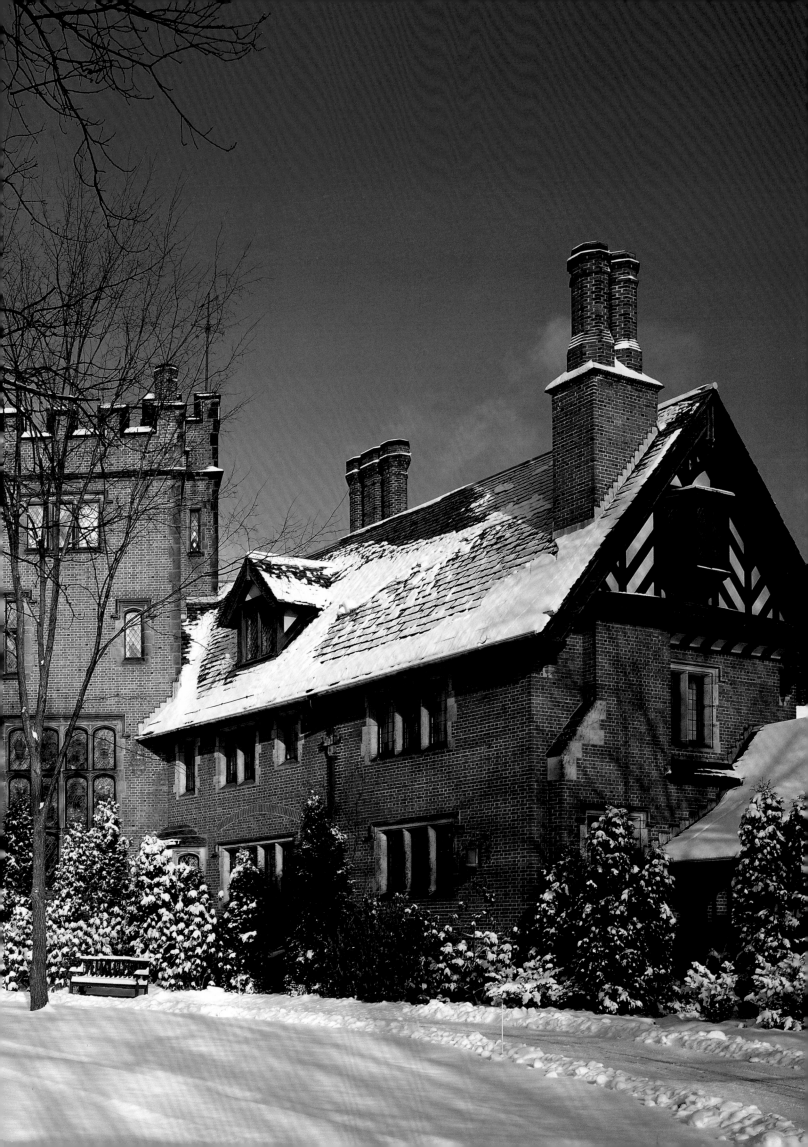

Oak Tree Reflections in Pool, West Terrace

Birch Allee at Night

Tower Staircase

F. A. Seiberling's Office

Desk Accessories,
F. A.'s Office

[163]

Billiard Room

Library

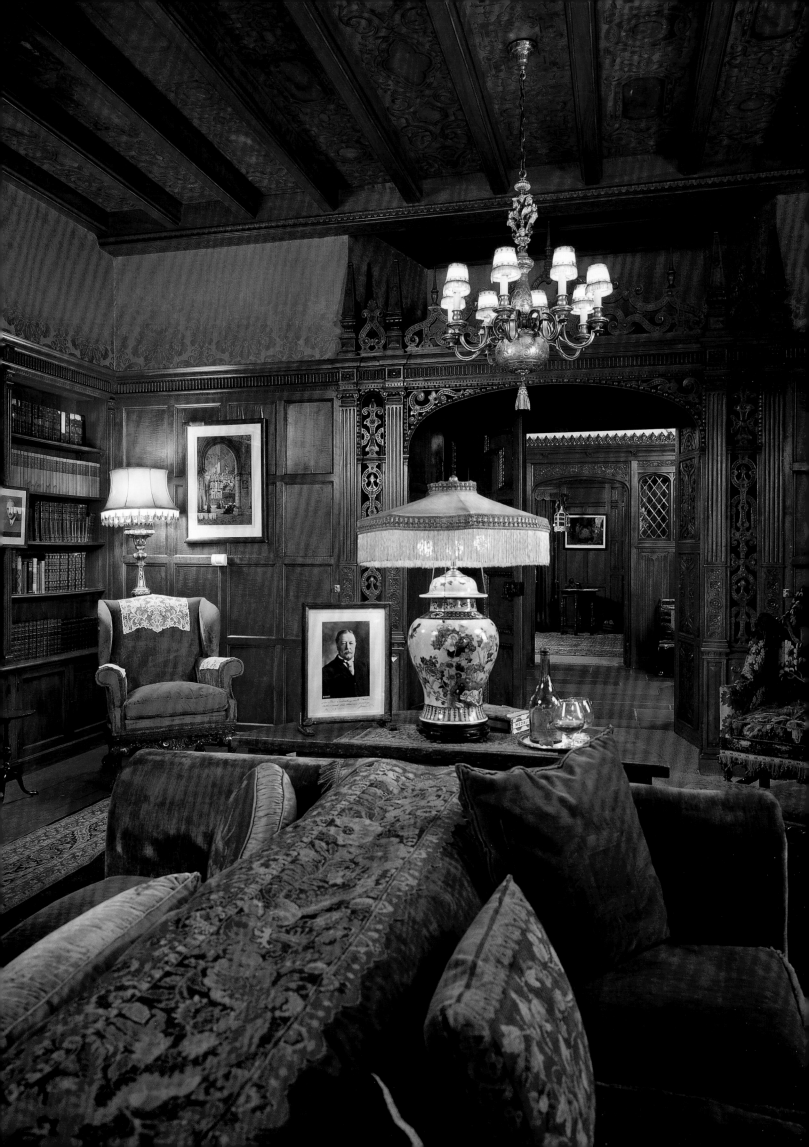

Mah-Jongg Game, Library

"Secret Passageway," Library

*Ivory Tusk and Desk
Accessories, Library*

*Portrait of Fred Seiberling,
Preserved Floral Arrangement,
Library*

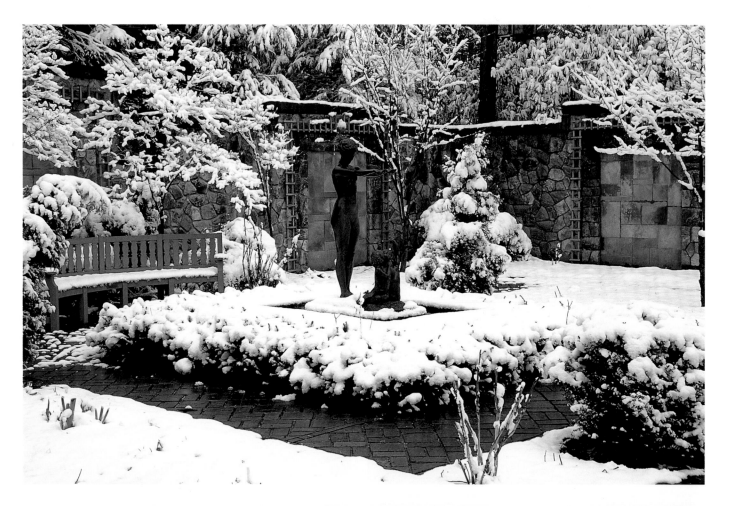

Water Goddess, English Garden

· *West Overlook*

Teahouses above Lagoon

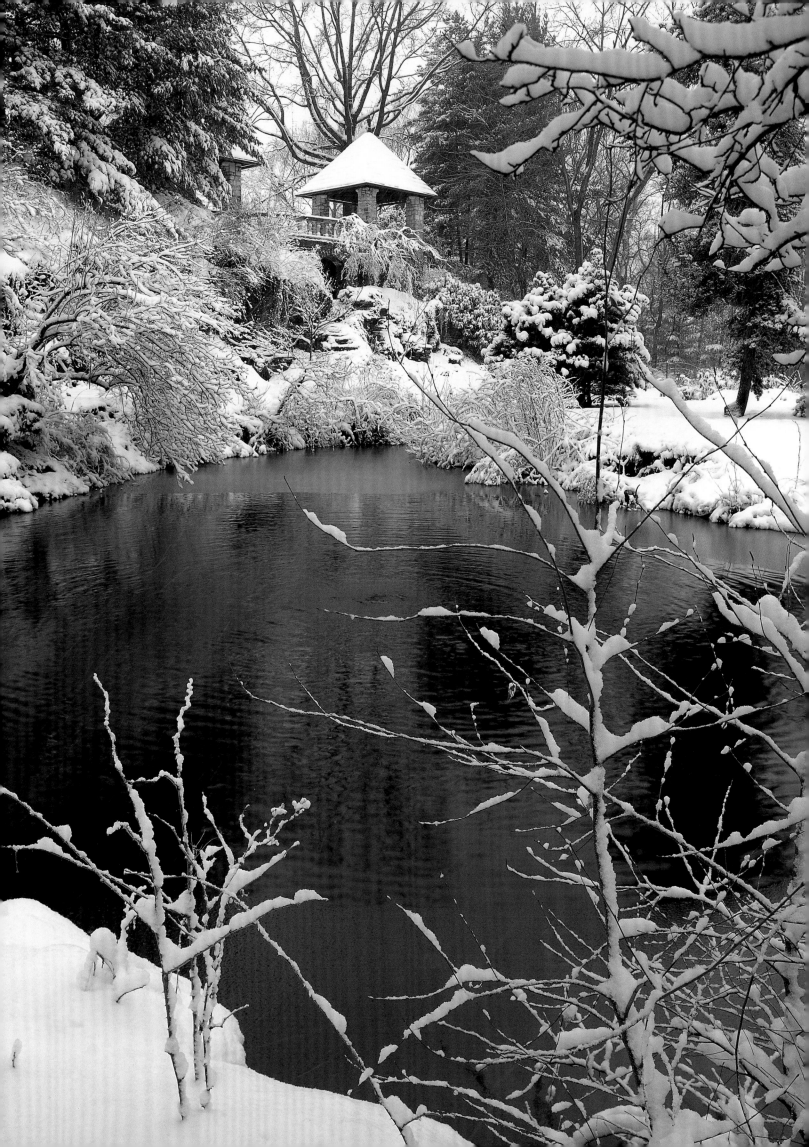

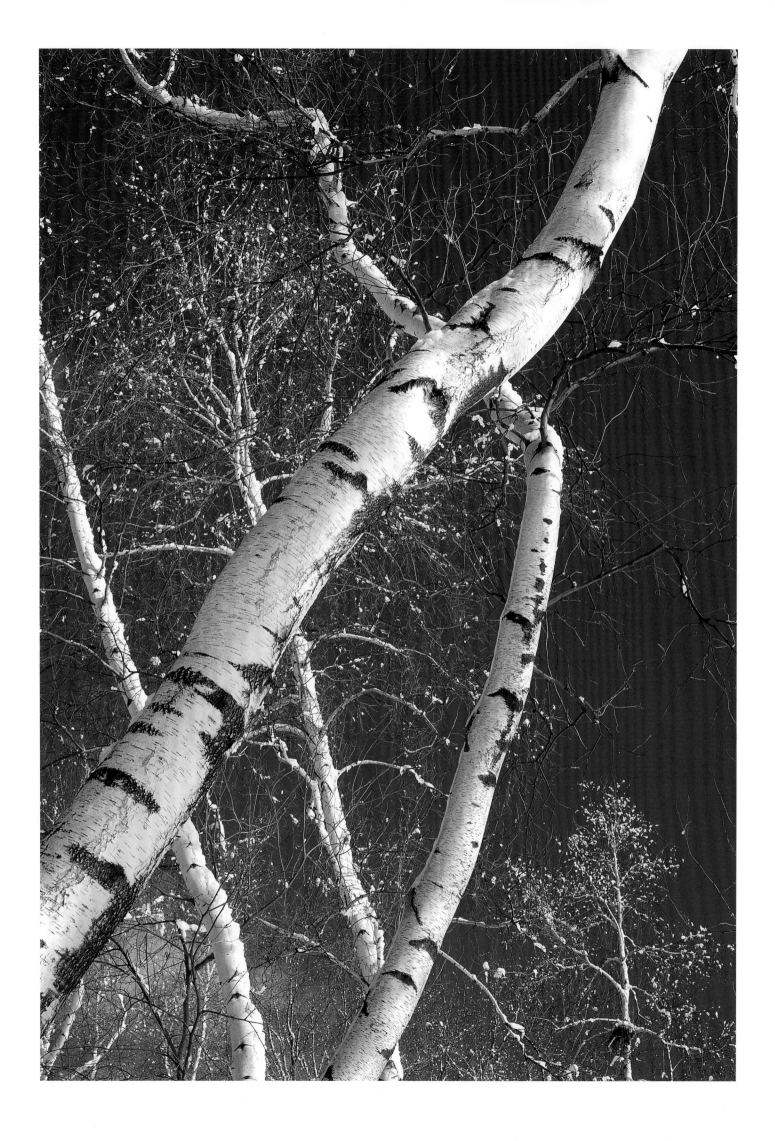

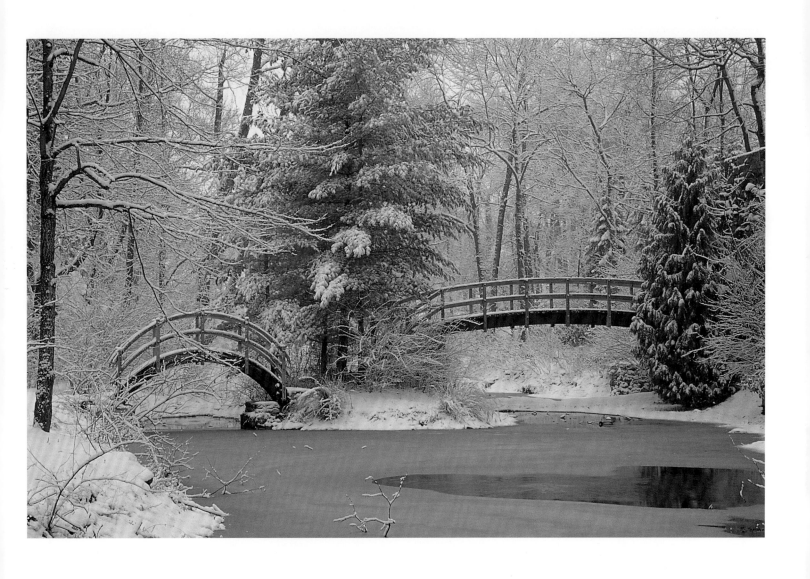

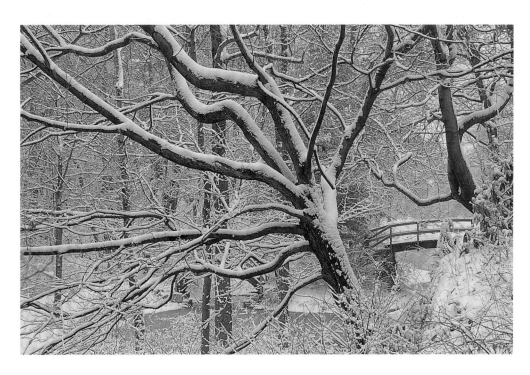

Birch Trees after Snow

Bridges, Lagoon

Lagoon

Overleaf: Music Room,
View from Musicians'
Balcony

[171]

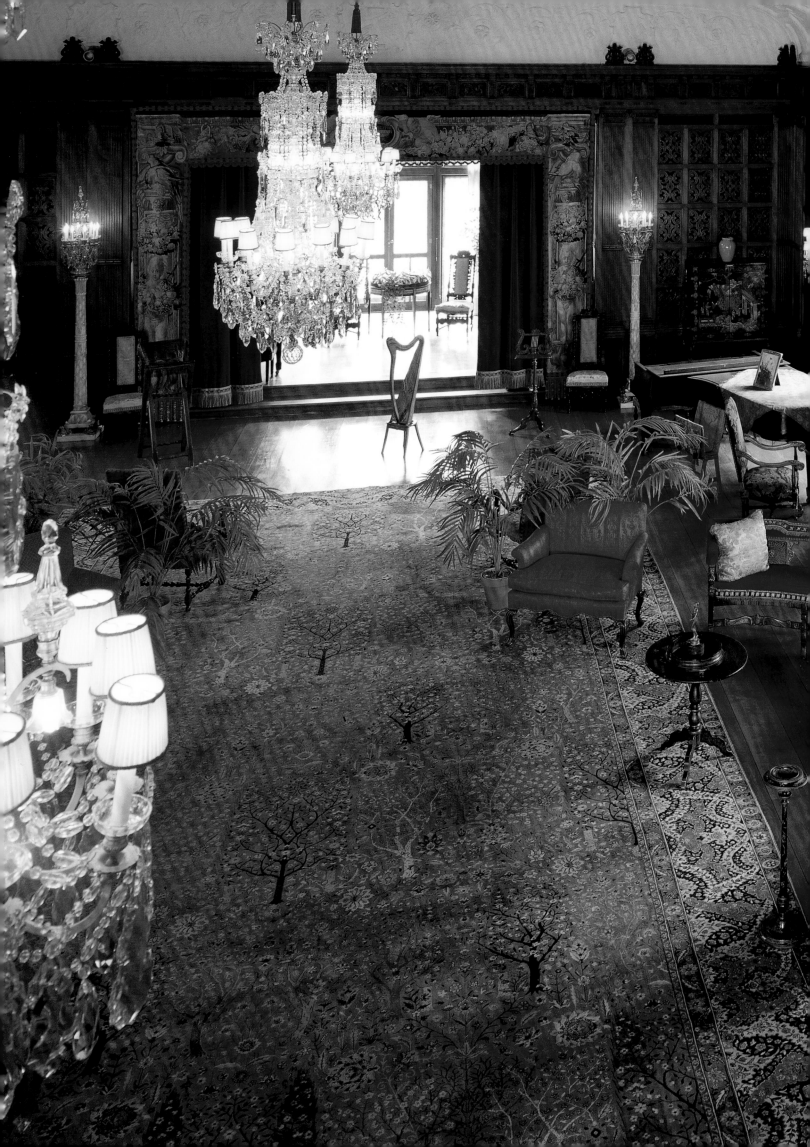

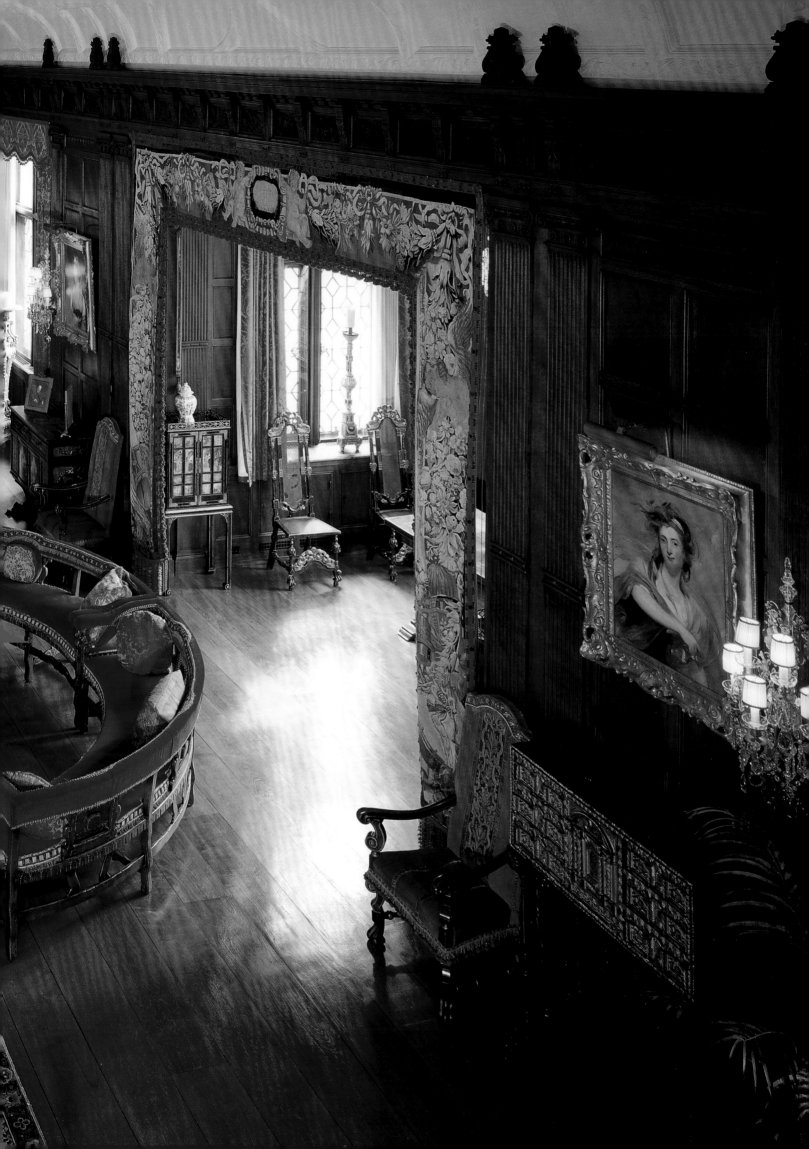

Music Room, View from West Porch Doorway

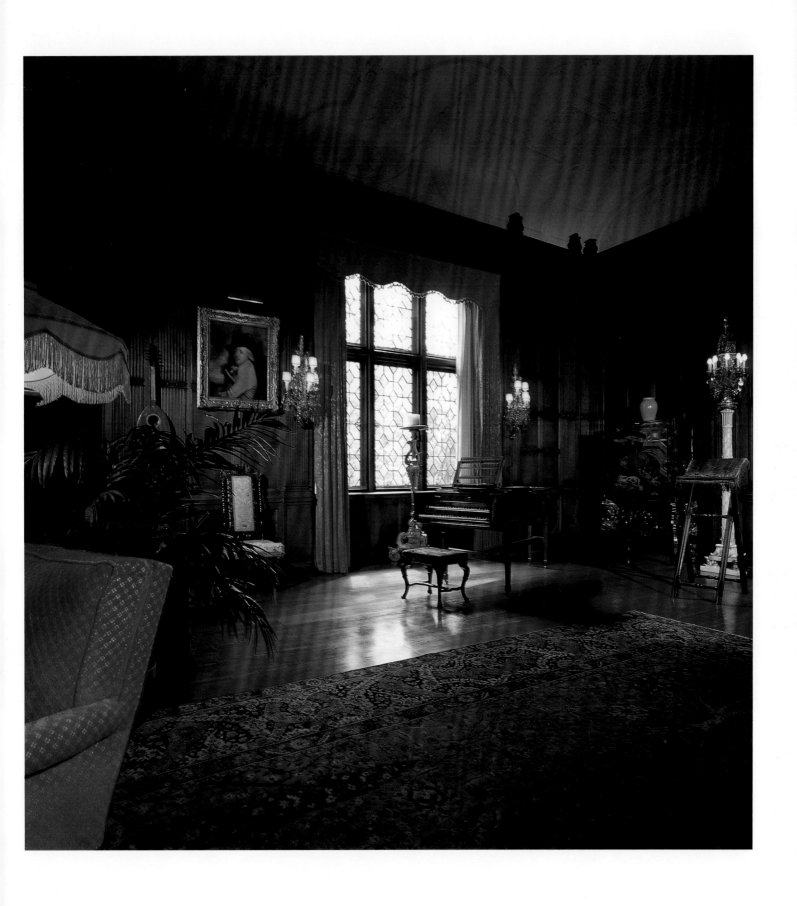

Eighteenth-century Harpsichord, Music Room

[175]

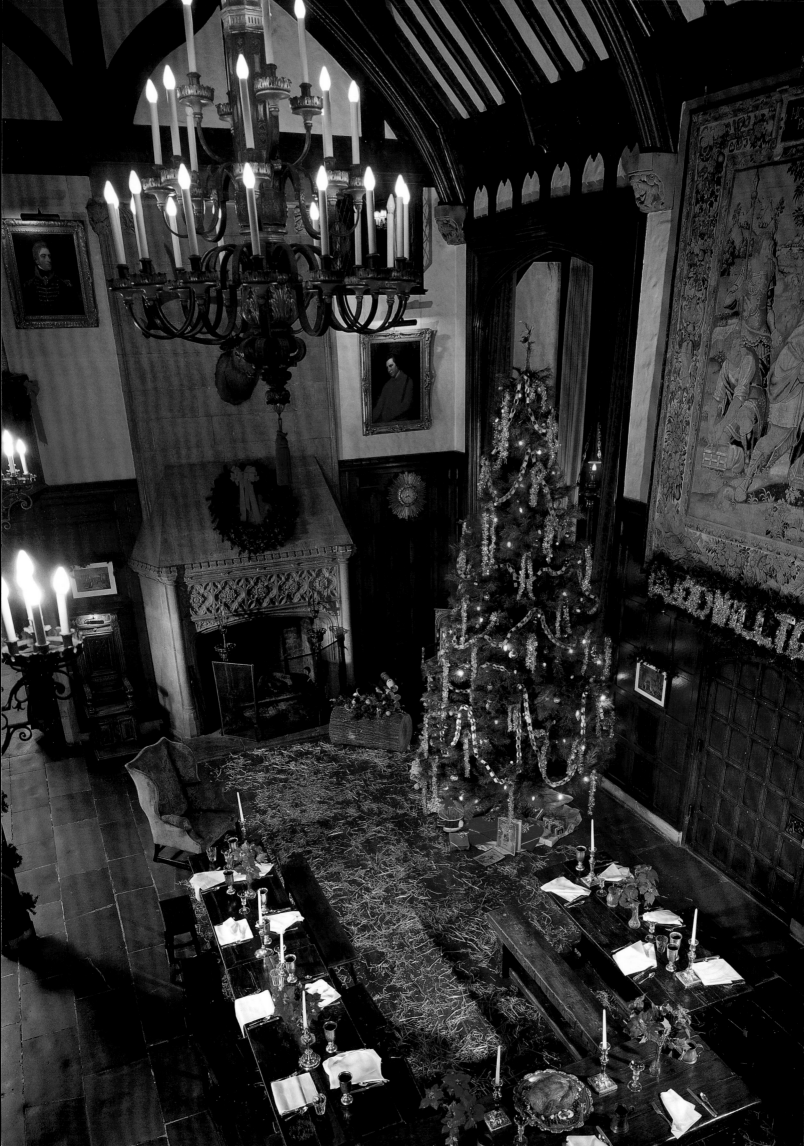

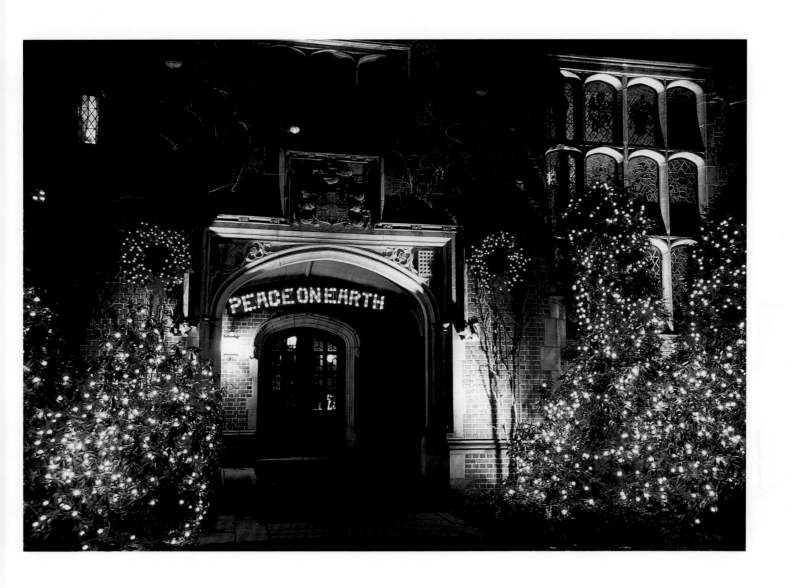

Christmas 1998, Great Hall

Christmas 1998, Main Entrance, Manor House

Grape Arbor, View to Conservatory

Holiday Lights, West Terrace Overlook

Overleaf: West Terrace

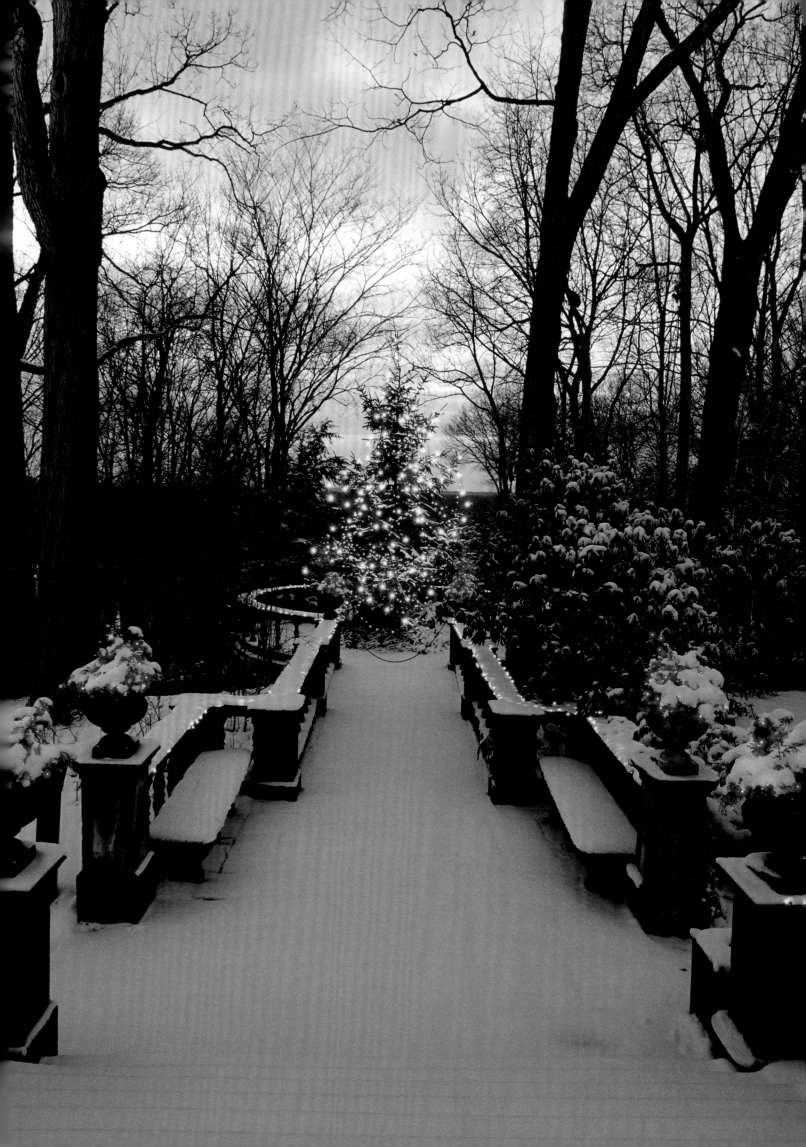

Evening Sky, West Terrace

Reflections on Pool,
West Terrace

Christmas 1998, Manor House

Overleaf: Oak Tree Reflections in
Pool, West Terrace

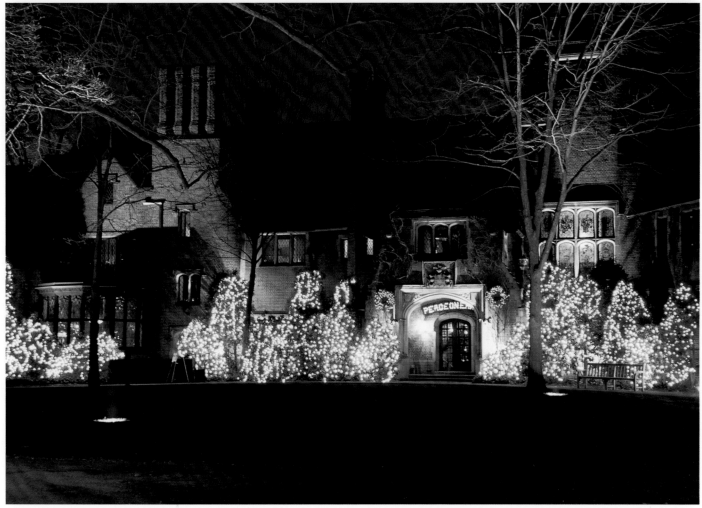

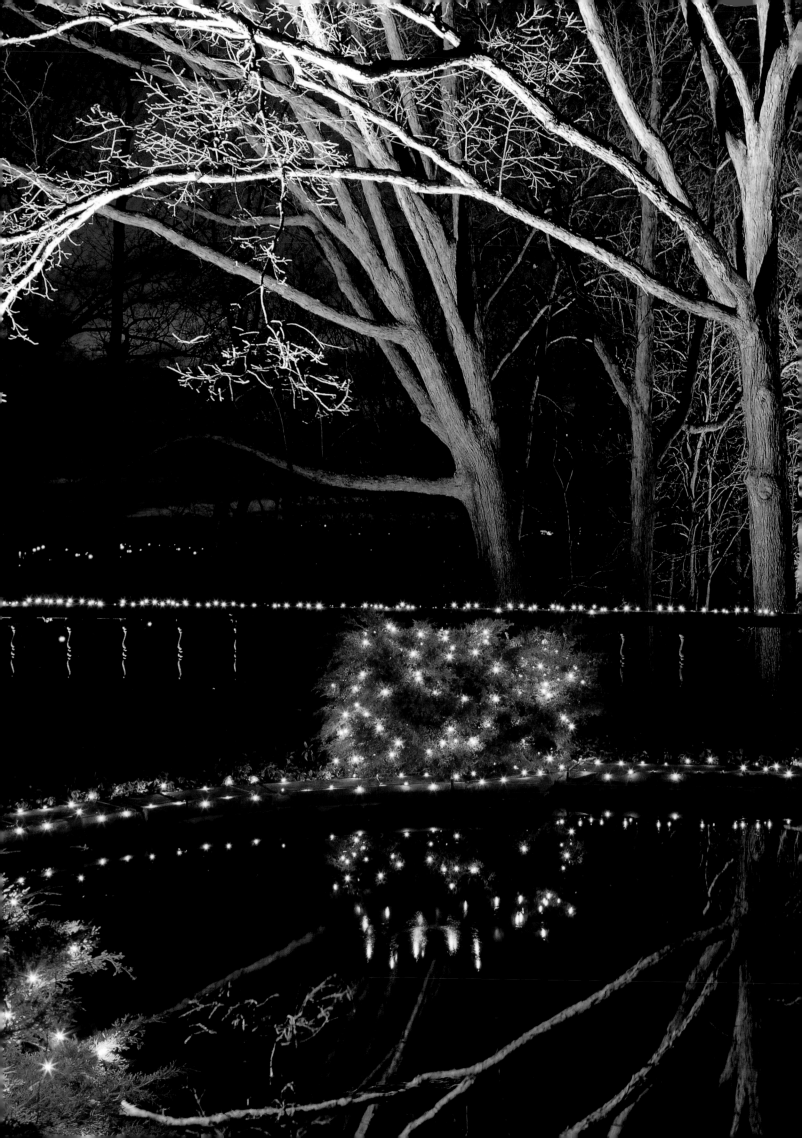

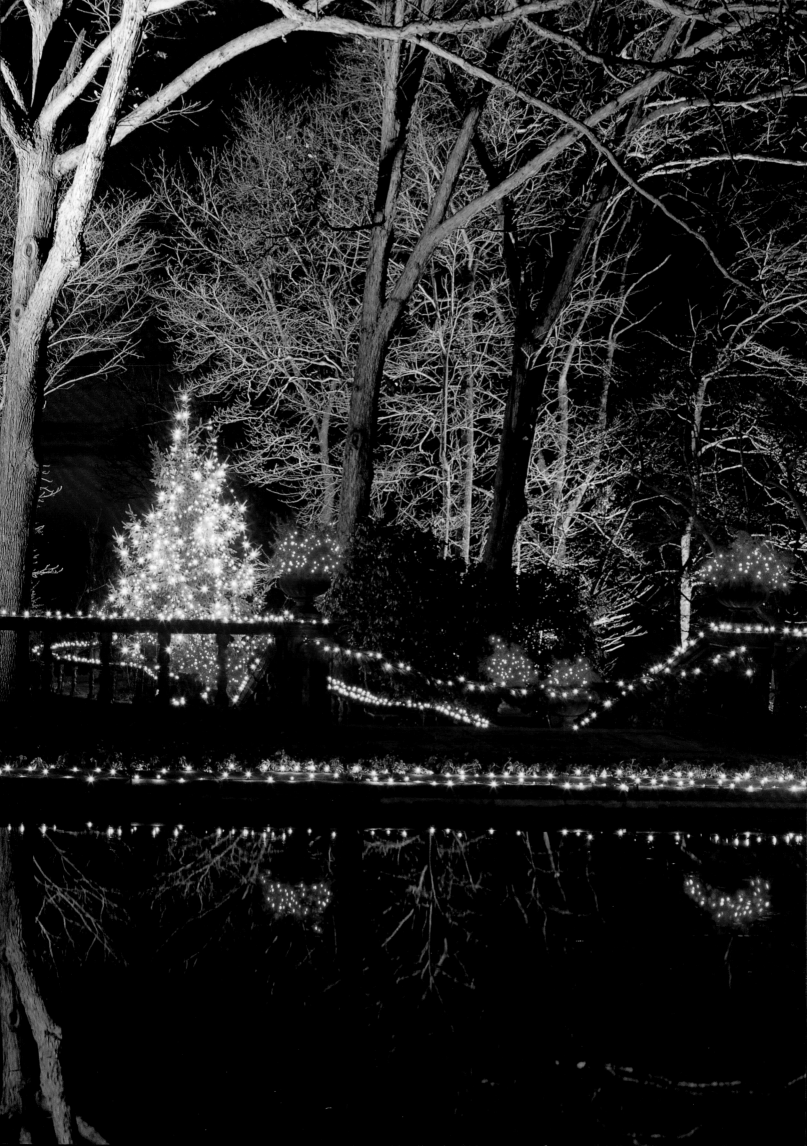

SOURCES

The Story of Stan Hywet Hall

Penfield Seiberling letter to Virginia and Jack Handy, Stan Hywet Hall and Gardens, Inc., Akron, Ohio, 7 August 1953.

Willard Seiberling letter to Virginia Handy, Stan Hywet Hall and Gardens, Inc., Akron, Ohio, 26 August 1955.

Seiberling family letter to Ohio State Archaeological and Historical Society, Stan Hywet Hall and Gardens, Inc., Akron, Ohio, May 1953.

Willard Seiberling letter to his children, Stan Hywet Hall and Gardens, Inc., Akron, Ohio, 9 September 1955.

The Irene Seiberling Harrison Collection, Stan Hywet House and Garden Tour, Stan Hywet Hall and Gardens, Inc., Akron, Ohio, June 1983.

Irene Seiberling Harrison, interview by Trevor Hoskins, The Goodyear Tire and Rubber Collection, University of Akron archives, Akron, Ohio, 1988.

"What Is The Tudor Period And Style?" by Franklin A. Seiberling Jr., Stan Hywet Hall and Gardens, Inc., Akron, Ohio, undated.

The Irene Seiberling Harrison Collection, recollections recorded by Charlene Thompson, Stan Hywet Hall and Gardens, Inc., Akron, Ohio, 9 March 1982.

The Irene Seiberling Harrison Collection, interview by Margaret Tramontine, Stan Hywet Hall and Gardens, Inc., Akron, Ohio, 10 April 1991.

The Irene Seiberling Harrison Collection, interview by Mark Heppner, Stan Hywet Hall and Gardens, Inc., Akron, Ohio, 6 April 1993.

Seiberling children's taped recollections (Irene Seiberling Harrison, Willard Seiberling, J. Penfield Seiberling, Frank A. Seiberling Jr.), Stan Hywet Hall and Gardens, Inc., Akron, Ohio, 28 April 1976.

F. A. Seiberling letter to Virginia Seiberling, Stan Hywet Hall and Gardens, Inc., Akron, Ohio, 19 May 1916.

Shakespeare Ball data, Stan Hywet Hall and Gardens, Inc., Akron, Ohio, 16 June 1916.

John Frederick Seiberling letter to Willard Seiberling, Stan Hywet Hall and Gardens, Inc., Akron, Ohio, 25 October 1918.

Irene Seiberling (unmarried at this time) letter to J. Frederick Seiberling, Stan Hywet Hall and Gardens, Inc., Akron, Ohio, 25 Septeber 1918.

John F. Seiberling, interviews by Steve Love, Akron, Ohio, 2 July 1996 and 30 April 1997.

Akron Beacon, society column concerning Irene Seiberling wedding, Akron, Ohio, 26 December 1923.

Akron Times Press, Stan Hywet Hall and Gardens, Inc., Akron, Ohio, 8 September 1928.

Louis A. Turner letter to J. Penfield Seiberling, Stan Hywet Hall and Gardens, Inc., Akron, Ohio, 5 April 1967.

Akron Beacon, society column quoting Sir Johnston Forbes-Robertson, Akron, Ohio, 4 April 1916.

John F. Seiberling interview, Stan Hywet Hall and Gardens, Inc., Akron, Ohio, 19 August 1992.

"Sport at Stan Hywet Hall," by Franklin A. Seiberling Jr., Stan Hywet Hall and Gardens, Inc., Akron, Ohio, 20 February 1983.

Akron Times Press, story of Mrs. Henry Ford visit to Stan Hywet, Akron, Ohio, 5 May 1931.

John F. Seiberling, foreword to The Story of Stan Hywet, Stan Hywet Hall and Gardens, Inc., Akron, Ohio, 3 March 1999.

Sally Harrison Cochran, interview by Steve Love, Akron, Ohio, 25 July 1996.

Mary Seiberling Chapman, interview by Steve Love, Akron, Ohio, 19 September 1996.

Georgia Schneider letter to the Seiberlings, Stan Hywet Hall and Gardens, Inc., Akron, Ohio, 28 April 1932.

Origins of Alcoholics Anonymous, a tape made by John Seiberling with his mother Henrietta Buckler Seiberling, Stan Hywet Hall and Gardens, Inc., Akron, Ohio, Spring 1971.

Domestic and Estate Staff compiled notes, Stan Hywet Hall and Gardens, Inc., Akron, Ohio, amended 20 May 1996.

Photograph of harpsichord by Marcy Nighswander, © Beacon Journal Publishing Co. All other photographs © Stan Hywet Hall and Gardens, Inc. Exterior and Interior photographs by Willard P. Seiberling.

Spring

Carl Ruprecht, interview by Steve Love, Akron, Ohio, 21 November 1998.

Seiberling children's taped recollections (Irene Seiberling Harrison, Willard Seiberling, J. Penfield Seiberling, Franklin A. Seiberling Jr.), Stan Hywet Hall and Gardens, Inc., Akron, Ohio, 28 April 1976.

Warren H. Manning letter to F. A. Seiberling, Stan Hywet Hall and Gardens, Inc., Akron, Ohio, 23 June 1911.

Warren H. Manning letter to Charles S. Schneider, Stan Hywet Hall and Gardens, Inc., Akron, Ohio, 27 March 1912.

Warren H. Manning memorandum of 12 July 1912 visit to Seiberling estate, Stan Hywet Hall and Gardens, Inc., Akron, Ohio, 18 July 1912.

F. A. Seiberling letter to Warren H. Manning, University of Akron archives, Akron, Ohio, 22 December 1912.

Warren H. Manning letter to F. A. Seiberling, University of Akron archives, Akron, Ohio, 25 May 1914.

F. A. Seiberling letter to Warren H. Manning, Stan Hywet Hall and Gardens, Inc., Akron, Ohio, 16 June 1914.

Warren H. Manning letter to F. A. Seiberling, Stan Hywet Hall and Gardens, Inc., Akron, Ohio, 25 June 1914.

Warren H. Manning letter to Gertrude Seiberling, University of Akron archives, Akron, Ohio, 10 July 1914.

Warren H. Manning letter to Gertrude Seiberling, Stan Hywet Hall and Gardens, Inc., Akron, Ohio, 4 August 1914.

Warren H. Manning letter to F. A. and Gertrude Seiberling, Stan Hywet Hall and Gardens, Inc., Akron, Ohio, 27 October 1914.

Warren H. Manning letter to William G. Dennis, Stan Hywet Hall and Gardens, Inc., Akron, Ohio, 8 April 1915.

Warren H. Manning letter to F. A. Seiberling, Stan Hywet Hall and Gardens, Inc., Akron, Ohio, 3 May 1915.

Warren H. Manning letter to F. A. Seiberling, Stan Hywet Hall and Gardens, Inc., Akron, Ohio, 10 February 1916.

Warren H. Manning letter to N. L. Palmer, Stan Hywet Hall and Gardens, Inc., Akron, Ohio, 7 March 1916.

Warren H. Manning memorandum of 8 and 9 May 1916, visit to Seiberling estate, Stan Hywet Hall and Gardens, Inc., Akron, Ohio, 9 May 1916.

Warren H. Manning memorandum of 20 April 1928, visit to Seiberling estate, Stan Hywet Hall and Gardens, Inc., Akron, Ohio, 27 April 1928.

Warren H. Manning report on Seiberling estate, Stan Hywet Hall and Gardens, Inc., Akron, Ohio, 7 November 1928.

Warren H. Manning letter to F. A. Seiberling, Stan Hywet Hall and Gardens, Inc., Akron, Ohio, 6 September 1932.

Jane Herron DuPree with Marlene Ginaven, *Outside/Inside: The Flowers of Stan Hywet* (Akron: Stan Hywet Hall Foundation, Inc., 1987).

J. Penfield Seiberling letter to William Snyder, Stan Hywet Hall and Gardens, Inc., Akron, Ohio, 14 July 1972.

"Creating Private Places for Flowers and Dreams," *New York Times,* 7 February 1997.

"Back in the Grove: An old apple orchard takes on new life at Stan Hywet Hall," *Akron Beacon Journal,* Akron, Ohio, 28 June 1996.

"Welcome to Stan Hywet Hall and Gardens" brochure, Stan Hywet Hall Foundation, Inc., Akron, Ohio, 1996.

Summer

Carl Ruprecht, interview by Steve Love, Akron, Ohio, 10 June 1999.

Domestic and Estate Staff compiled notes, Stan Hywet Hall and Gardens, Inc., Akron, Ohio, amended 20 May 1996.

Grace Seiberling Chase dictated story to Catherine Seiberling Stewart as a memorial to Dr. William Chase, Stan Hywet Hall and Gardens, Inc., Akron, Ohio, Spring 1950.

"A Stan Hywet Butler of Parts," by Franklin A. Seiberling Jr., Stan Hywet Hall Foundation, Inc., Newsletter, Akron, Ohio, July 1987.

Stan Hywet Hall and Gardens staff, "Doorbells, Dustpans & Dishpan Hands: Domestic Staff at Stan Hywet Hall," Stan Hywet Hall and Gardens, Inc., Akron, Ohio, 1997.

"Sport at Stan Hywet Hall," by Franklin A. Seiberling Jr., Stan Hywet Hall and Gardens, Inc., Akron, Ohio, 8 March 1983.

"Make the Most of Your Lawn," by James Meyers (New York: Hart Publishing Company, Inc., 1978).

"These Industrial Leaders Score Golf," *Akron Beacon Journal*, 28 June 1932.

Cedar Lodge, Les Cheneaux Islands, Hessel, Michigan, a real estate brochure, 1951.

Fall

Carl Ruprecht, interview by Steve Love, Akron, Ohio, 10 June 1999.

The Irene Seiberling Harrison Collection, Irene Seiberling Harrison letter to Aunt Ida (no last name), Stan Hywet Hall and Gardens, Inc., Akron, Ohio, 1 October 1938.

Virginia "Ginny" Seiberling Handy biographical summary, Stan Hywet Hall and Gardens, Inc., Akron, Ohio, amended 1999.

John "Jack" Littlefield Handy biographical summary, Stan Hywet Hall and Gardens, Inc., Akron, Ohio, amended 1999.

Seiberling family events summary, Stan Hywet Hall and Gardens, Inc., Akron, Ohio (no date).

Akron Beacon Journal, society column announcing impending marriage of Virginia Seiberling, Akron, Ohio, October 1919.

Akron Beacon Journal, Virginia Seiberling-John Handy wedding story, Akron, Ohio, 5 October 1919.

Willard Seiberling letter to Virginia Seiberling, Stan Hywet Hall and Gardens, Inc., Akron, Ohio, Spring 1919.

J. Penfield Seiberling letter to Irene Seiberling Harrison, Stan Hywet Hall and Gardens, Inc., Akron, Ohio, October 1929.

Mary Seiberling Chapman interview, Stan Hywet Hall and Gardens, Inc., Akron, Ohio (no date).

The Irene Seiberling Harrison Collection, Irene Seiberling Harrison letters, Stan Hywet Hall and Gardens, Inc., Akron, Ohio, 1927, 1938.

Jack Handy letter to F. A. Seiberling, Stan Hywet Hall and Gardens, Inc., Akron, Ohio, 23 December 1948.

F. A. Seiberling letter to Irene Seiberling Harrison, Stan Hywet Hall and Gardens, Inc., Akron, Ohio, 18 November 1948.

Robert Bowman (husband of Sylvia Handy Bowman) letters to (Stan Hywet Hall Foundation, Inc.), Stan Hywet Hall and Gardens, Inc., Akron, Ohio, 10 May 1988 and 23 June 1995.

J. Penfield Seiberling letter to Irene Seiberling Harrison, Stan Hywet Hall and Gardens, Inc., Akron, Ohio, 14 September 1937.

Programs, Fiftieth Wedding Anniversary of Frank A. and Gertrude P. Seiberling, Stan Hywet Hall and Gardens, Inc., Akron, Ohio, 10 October 1937.

Akron Beacon Journal, Seiberlings' Fiftieth Anniversary Musicale, Akron, Ohio, 13 October 1937.

Winter

The Irene Seiberling Harrison Collection, Irene Seiberling Harrison Christmas essay, Stan Hywet Hall and Gardens, Inc., Akron, Ohio, 9 November 1992.

Seiberling family Christmas cards, Stan Hywet Hall and Gardens, Inc., Akron, Ohio, various years.

Gertrude Seiberling Christmas menu, Stan Hywet Hall and Gardens, Inc., Akron, Ohio, year unknown.

Seiberling Christmases, Stan Hywet Hall and Gardens Interpreter's Manual, Stan Hywet Hall and Gardens, Inc., Akron, Ohio, 1919, 1923, 1930.

Seiberling Christmases, Stan Hywet Hall and Gardens Training Manual, Stan Hywet Hall and Gardens, Inc., Akron, Ohio, 1991.

"The Seiberling Family Christmas," a poem by J. Penfield Seiberling, Stan Hywet Hall and Gardens, Inc., Akron, Ohio, 1930.

Jack (John) L. Handy Jr., Holiday Research Questionnaire, Stan Hywet Hall and Gardens, Inc., Akron, Ohio, 20 April 1993.

Anabel Handy Kirby, Holiday Research Questionnaire, Stan Hywet Hall and Gardens, Inc., Akron, Ohio, 13 April 1993.

Julia Seiberling Shaw, Holiday Research Questionnaire, Stan Hywet Hall and Gardens, Inc., Akron, Ohio, June 1993.

Anne Seiberling Davis, Holiday Research Questionnaire, Stan Hywet Hall and Gardens, Inc., Akron, Ohio, June 1993.

Nancy Seiberling, Holiday Research Questionnaire, Stan Hywet Hall and Gardens, Inc., Akron, Ohio, June 1993.

John F. Seiberling, interviews by Steve Love, Akron, Ohio, 2 July 1996 and 30 April 1997.

John F. Seiberling interview, Stan Hywet Hall and Gardens, Inc., Akron, Ohio, 19 August 1992.

The Irene Seiberling Harrison Collection, Irene Seiberling Harrison interview by Margaret Tramontine, Stan Hywet Hall and Gardens, Inc., Akron, Ohio, 10 April 1991.

Seiberling children's taped recollections (Irene Seiberling Harrison, Willard Seiberling, J. Penfield Seiberling, Frank A. Seiberling Jr.), Stan Hywet Hall and Gardens, Inc., Akron, Ohio, 28 April 1976.

Sally Harrison Coehran, interview by Steve Love, Akron, Ohio, 25 July 1996

PHOTO INDEX

PHOTOGRAPHS BY IAN ADAMS

ALL PHOTOGRAPHS INDEXED BY PHOTOGRAPHER

Series on Ohio History and Culture